John K. Flores

LOUISIANA
Birding

—— . ——

Stories on Strategy,
Stewardship & Serendipity

THE
History
PRESS

Published by The History Press
Charleston, SC
www.historypress.com

Copyright © 2018 by John Flores
All rights reserved

Unless otherwise credited, images are from the author's collection.

First published 2018

Manufactured in the United States

ISBN 9781467140942

Library of Congress Control Number: 2018945670

CONTENTS

Contents

ACKNOWLEDGEMENTS

*T*o my precious wife, Christine, whom I've sat side by side with processing pictures following one of our nature-viewing adventures. Thank you for putting up with my wild hairs chasing something in the woods and marsh. No matter how tough the terrain, how hot or cold the weather is or what time we have to get up before daylight to get to where we're going, you never complained, especially when you've snapped shutters next to me—always hoping one of us would get *the* shot.

To my children, Crystal, Jason, David and Joshua, you guys are always jazzed about my endeavors and encouraging with your words and excitement.

To Danny Womack, my mentor and friend. Thanks for opening up the world of nature photography to me. I'll never forget our first shoot together on your duck pond near Forked Island. It was blue-winged teal that day. Your gentle critiques and encouragement during those early years helped me get better.

To Dr. Terry Jones, thanks for taking time to edit my manuscript. Your thoughts were always taken seriously and helped me to create this work. I've always valued our friendship. What's more, you and Carol have been a blessing to my family over the years.

To Michael Seymour, no matter what time of day or night I call, you pick up the phone to answer my questions.

To Carrie Salyers, thank you for your seemingly endless work helping keep the public in the know by generating whooping crane updates, newsletters and educational events. You've always been a tremendous help to me.

To Michael Carloss, from pelican reintroduction to the role you played during the BP oil disaster, your dedication to your work with the Louisiana Department of Wildlife and Fisheries remains an inspiration. You made writing about department activities easy.

To Paul Link, thank you so much for all of the text message invites to get out in the field with your team banding waterfowl. It's hard keeping up sometimes; you're like a machine focused on a mission. But in the end, there is always a great story involved.

To John Arvin, Dr. Erica Miller, the late Tom Hess, Jay Huner, Jereme Phillips, Paul Yakupzack, Phillip Vasseur, Tyson Crouch, Dr. Andrew Ramey, Katie Percy, James Whitaker, Samantha Collins and John Fitzpatrick, thank you for your wonderful comments from interviews over the years that make these stories interesting and so enjoyable to write about.

To the Louisiana Department of Wildlife and Fisheries, the United States Fish and Wildlife Service, Audubon Louisiana, the Nature Conservancy, Ducks Unlimited, Delta Waterfowl, Cornell Lab of Ornithology, Friends of Bayou Teche National Wildlife Refuge and the league of biologists, technicians and volunteers who devote themselves to the work of ensuring birds along the bayou will always be with us.

INTRODUCTION

*O*ne summer evening a number of years ago, I sat on the back patio of my good friend Jimmy Wilson's bayou-side home. He and his wife, Pauline, happen to live on Bayou Teche in Centerville, Louisiana. Their home rests on the north side of the bayou across the road from perhaps a couple thousand acres of sugar cane fields. Behind the agricultural fields is a levee that separates Centerville from the Atchafalaya Basin. In short, he and Pauline live in a migratory bird thoroughfare.

Jimmy and I have spent many years hunting the marsh together. One evening, beneath the canopy of live oaks in his backyard, we were sipping coffee and reminiscing a bit when, from somewhere above, a prothonotary warbler began to sing.

I asked my friend if he had ever seen the bird that was singing, telling him that I spend a lot of time on Bayou Teche National Wildlife Refuge—down the road near his place—each spring observing neotropical songbirds.

His reply was like so many others. He hadn't. Moreover, over the years, he had paid little attention to its sweet and beautiful song. Like the sound of traffic in a big city, so often the singing of songbirds goes unnoticed. It has always been there simply as background noise. Therefore, by and large, it is tuned out.

During the ensuing conversation with my friend, I told him I couldn't believe all of the years I spent hunting our region and never saw these birds either. In fact, sadly, I never took the time to. The consumptive outdoor activities of my lifestyle dominated the non-consumptive. Hiking, canoeing

and boating were always activities I'd parlay into some sort of hunting and fishing activity that had, in my opinion, more purpose.

My introduction to birds along the bayou came from another dear friend with whom I spent time hunting waterfowl, not only with a shotgun but also a camera after the season ended. Becoming my mentor, he and I exchanged waterfowl pictures; one day, he sent me an image of a painted bunting. Having never seen such beauty, I asked him where he'd taken it. Come to find out, the place wasn't far from his home in Lafayette, Louisiana.

I couldn't believe such birds existed in the marshes and woods I had fished and hunted for so many years. Suddenly, the scales fell off of my eyes, and they were opened to a whole new world of beauty. The songbirds now reappear every time I go to the bottomland hardwoods of the Atchafalaya Basin, the upland piney woods and the coastal marshes.

Today, I miss few birds that dart past my peripheral vision. At times, I find it difficult to hold a conversation with someone outside when a warbler or bunting sings on a cool spring morning. Quite often, I suddenly find myself interrupting the other person for a moment, asking them something related to the bird

In the past decade, I've spent time traveling around the state as an outdoor writer covering a wide range of topics and stories. Perhaps none has received more favorable response from readers than those dealing with birds—these conspicuous feathered friends that surround us with their glory.

Louisiana is known as the sportsman's paradise when it comes to hunting and fishing. Yet few states compare when it comes to the diversity of birds, including passerines, wading birds, raptors and shorebirds, that people have the opportunity to see throughout the year. In fact, Louisiana is considered one of the top five birding states.

However, Louisiana is more than a birding state. The Louisiana Department of Wildlife and Fisheries—working in concert with the United States Fish and Wildlife Service and numerous stakeholders, agencies and academic institutions such as LSU, Audubon Louisiana, the Nature Conservancy, Ducks Unlimited, Delta Waterfowl and others—has literally supported and brought certain species of birds from the brink of extinction and supported conservation efforts for other species that flourish in the state today.

My hope is that *Louisiana Birding* brings to the forefront the achievements made by these state, federal and private agencies, and moreover, recognizes the collective investment of capital, time, science and physical effort the various departments have put in over the years with the hope of preserving the avian heritage of our state.

Additionally, just like the sun that gives light to each new day, may this work brighten your path in the Louisiana wilds of learning. And may the birds you've never seen before on these pages give you as much pleasure as they have given me.

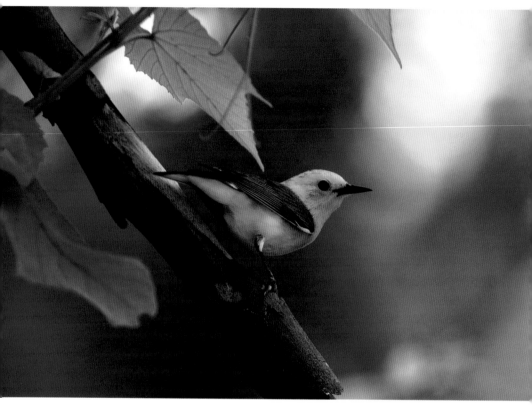

Prothonotary warblers are the greeters along the bayou. Their song is a tribute to the beauty of the basin.

1

ACADIANA SUNRISE SYMPHONY

The Annual Bird Migration

From above the canopy of the bottomland hardwoods, rays of light stretch through the tree branches to the forest floor below. Much like a child yawning, pushing his arms through the air, the light reaches the understory and once again ushers in a new day.

Kissing the leaves of the cottonwood, sycamore and overcup oaks, the sunlight spills onto the briars, rubus and ferns below that make up the hardwood's carpet—creating brilliant hues of yellow and green.

Somewhere, a red-breasted woodpecker taps like a conductor. The chirping sound from insects that gathered before daylight quiets, and suddenly, the morning is filled with music provided by a choir of songbirds.

The surrounding woods, swamps and marshes of Acadiana that make up the Atchafalaya Basin are not only major thoroughfares for some migrating birds, they also act as important wintering and breeding grounds for others. As certain species leave, others arrive, and early spring is the perfect time of year to enjoy watching these temporary visitors around the state of Louisiana.

The Cornell Lab of Ornithology's executive director, John W. Fitzpatrick, during a winter tour of southwest Louisiana, once referred to Louisiana's river and delta regions as the Amazon of North America. "It's a major system, rich in productivity," he expounded.

Michael Seymour, a non-game avian biologist for the Louisiana Heritage Program, which is an arm of the Louisiana Department of Wildlife and Fisheries, calls the Atchafalaya Basin a phenomenal place with tremendous

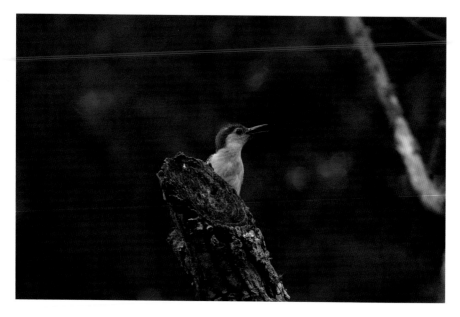

Above: The red-bellied woodpecker is a year-round resident of the swamps and hardwoods. Its noisy vocals are a giveaway to its presence in the woods.

Opposite: Red like a northern cardinal and often mistaken for one at first glance, the summer tanager spends the spring and summer months in the bottomland hardwoods of Louisiana.

bird densities and breeding habitat. And in fact, it does have one of the largest populations of songbirds in the entire United States.

Some 20 miles wide and 150 miles long, the Atchafalaya Basin's land mass represents 1.4 million acres. Moreover, it is the largest existing wetland in the entire United States.

During the early part of spring, you have wintering birds that are still hanging around and some waterfowl leaving. Some of the wading birds that may have gone farther south are starting to return to the basin. Birds like American gold finches, known to nest north of Louisiana, will stick around for a long time in this rich habitat following winter. The blue-winged teal will often lazily hang around until May before making its trek north to the breeding grounds of the upper Midwest and Canada.

There are over three thousand species of birds that live in the neotropical region of Central and South America. For millennia, many of them have made a northern trans-gulf migration by crossing—in some cases—over eight hundred miles of open water each spring, only to repeat the process south in late summer and early fall.

Rarely observed in its summer plumage as pictured, the American gold finch is a common winter resident of Louisiana.

Beachcombers walking the high tide wrack lines of Rutherford and Holly Beaches in southwest Louisiana and Elmer's Island and Grand Isle Beaches of southeast Louisiana will often find the carcasses of dead birds. Sadly, their destiny was a watery grave because they lacked the energy in the form of body fat to make the trek across the Gulf of Mexico.

Approximately 150 of those 3,000 species of birds migrate to North America each spring to their breeding grounds. Considering there are roughly 900 species of birds in North America, a significant number make the Atchafalaya Basin their destination of choice. It is the richness of the ecosystem in both habitat and food sources that makes the basin so important and popular to these travelers.

A white-eyed vireo's striking eye leaves no doubt as to its identity. White-eyed vireos are common throughout the spring and summer along the bayou.

Seymour, who has been a birdwatcher from a very young age, said of these visitors:

> *In general, things come south to find food resources. Ducks, for instance, are forced south because the waters are freezing and they're trying to find open water to forage. For things like birds that you find in the woods, they're searching out fruits, insects and other invertebrates. The insects up north are either going to be hibernating, so to speak, dead, or in a lifecycle where they are buried beneath several feet of snow. Obviously, here in Louisiana we have mosquitoes—even in the winter—so birds like warblers and swallows will eat those.*

Although year-round residents, raptors such as Cooper's, red-shouldered, red-tailed and sharp-shinned hawks also migrate to the region from farther

north in the United States in search of food sources. That food is often the smaller songbirds that make the region their temporary winter home. What's more, Seymour admitted, these birds are the ones he gets the most complaints about when they pick off small birds at residential backyard feeders. "Unfortunately, raptors have to eat too," the biologist informs the callers.

For the neotropical songbirds that leave such a cornucopia in the basin and migrate south into Mexico and Central America in late summer and early fall, it is theorized this may be due to less competition for food resources or possibly a total change in diet. But it is the basin's rich habitat that causes them to return to breed each spring.

The tiny Carolina chickadee is a year-round resident of Louisiana. Its distinct song is easily recognized.

In describing the Atchafalaya Basin, Seymour pointed out that besides being the largest wetland, as previously noted, it also is one of the largest continuous tracks of bottomland hardwood forests in our nation.

Seymour also noted that you can walk into the basin's forest where the trees look to be thirty years old and are already forty to fifty feet tall. By contrast, that same forest in the northern United States is dwarfed by comparison and not all that impressive. But in the Atchafalaya Basin, the soils are so exceptional and the growing season so protracted that plants do extremely well, which leads to more insects and, in turn, more birds.

They're coming back to the Atchafalaya Basin because it's certainly and absolutely one of the richest places in the United States as far as productivity. The sheer biomass of the basin is unsurpassed. As such, nothing else compares to it in the country.

Since 2004, the Atchafalaya Basin has also served as an excellent stage and important habitat for capturing and banding birds for the Louisiana Department of Wildlife and Fisheries (LDWF) Monitoring

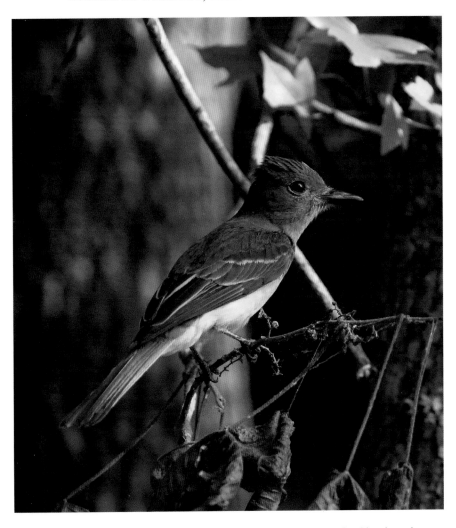

While the great-crested flycatcher may lack the colors of other bottomland hardwood inhabitants, he is no less ornate with yellow- and rust-colored feathers that enhance its buff-brown and gray colors.

Avian Productivity and Survivorship (MAPS) program each year. MAPS monitoring helps avian biologists by providing critical population and bird distribution estimates, which, in turn, become vital data for conservation and management efforts.

Through 2014, Seymour and a group of LDWF technicians, as well as volunteer graduate students, set up mist nets in eight locations to capture and band birds around the state. Three of those were in the Atchafalaya Basin, two on Sherburne Wildlife Management Area and one on the

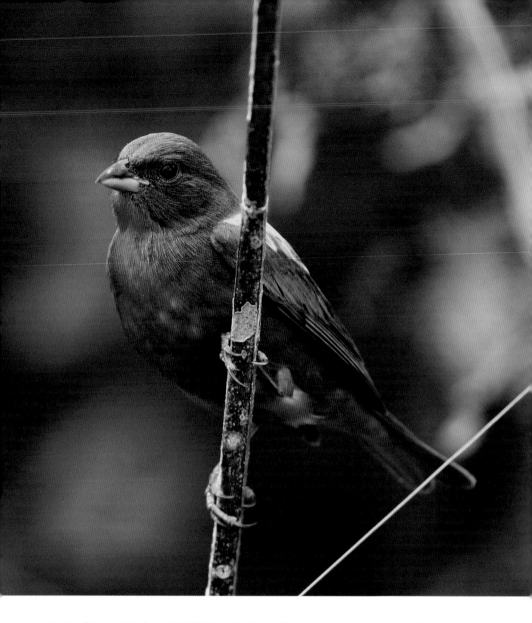

Atchafalaya National Wildlife Refuge. Today, the biologist utilizes only one site: Pearl River Wildlife Management Area along the Louisiana/ Mississippi state line.

Mist nets are set up in pairs, then checked simultaneously after a prescribed time period to compare data. Additionally, the mist nets and subsequent captures are conducted in different timber types and natural areas.

Unlike waterfowl banding, in which biologists know the birds they are targeting, Seymour refers to his studies as *captures* because of the number he and his technicians release and don't band. Essentially, the team doesn't carry

Right: Indigo buntings, which have a beautiful regal blue hue, grace the edges of marshes and wooded areas around the state.

Below: The hooded warbler lives in the bottomland hardwoods throughout the state of Louisiana during the summer months. By April, its song is regularly heard in the bottomland hardwoods.

Opposite: Is there another bird in full regalia more beautiful than the painted bunting? It represents splendor along the bayou.

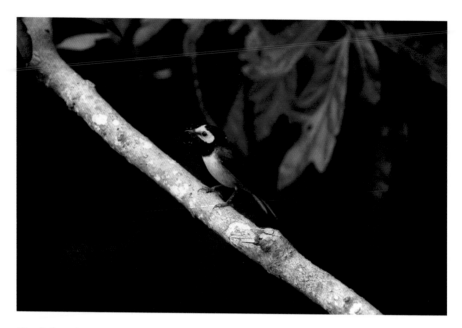

Hooded warblers aren't particular about what they feed on—like this garden spider.

large enough bands for some of the bigger birds—like common grackles or crows—so these are not banded. Hummingbirds require a special permit, so they typically aren't banded by the MAPS team and are therefore released.

The department averages 2,800 captures each year and overall has captured approximately 25,000 birds since the program began.

Sherburne Wildlife Management Area (WMA) and the Atchafalaya National Wildlife Refuge (NWR), as a birding location, is a destination people can go to enjoy these migrants once they return to the Atchafalaya Basin each spring and throughout the summer. The forty-four-thousand-acre refuge is managed by the LDWF but owned by three agencies: the U.S. Army Corps of Engineers, the U.S. Fish and Wildlife Service (Atchafalaya NWR) and the LDWF (Sherburne WMA).

To reach this part of the upper Atchafalaya Basin, visitors can take Exit 127 along I-10 and drive north on L.A. 975. Known as the Whiskey Bay Highway, the road runs parallel with the Atchafalaya River northward to Krotz Springs.

Neotropical songbirds are found in abundance along L.A. 975 between I-10 and U.S. 190. In fact, this twenty-mile stretch of gravel road falls in the top-ten places number-wise during the annual North American Breeding Bird Surveys. Nowhere were they celebrated more than during the Neotropical Songbird

The blue-gray gnatcatcher has an eyebrow that gives it an angry look. This tiny bird is common in marshy habitats.

Tours, previously held on Mother's Day weekend each year at Sherburne Wildlife Management Area.

Most residents of Louisiana's coastal prairie, oak-lined cheniers and the Atchafalaya Basin know and are familiar with common flocking winter birds, such as puddle ducks, tree swallows, white pelicans and robins. But other winter birds that hang around until spring include the yellow-rump warbler (a.k.a. Audubon's warbler and myrtle warbler) and the blue-gray gnatcatcher—although the blue-gray gnatcatcher is known to breed in the region and also considered a year-round resident.

It was a camera-shy blue-gray gnatcatcher that visited me on the deer stand several times one winter that changed the way I think, as far as birdwatching is concerned.

Long periods of time without seeing deer can be discouraging. With the gnatcatcher within feet of me and often too busy to pose, I spent three straight weekends trying to catch an image of it while hunting. When I finally was able to snap the shutter, I was nearly as proud of this trophy picture as I would have been a ten-point buck on the wall.

Neotropics arriving along the bayou in the spring can be breathtaking. Novice birdwatchers will become speechless at their first glimpse through a pair of binoculars or camera lens of a prothonotary warbler or indigo or painted bunting.

More skilled birdwatchers often communicate with one another through birding clubs, when transients such as magnolia, bay-breasted, blue-winged and Blackburnian warblers are spotted during the spring migrations. Many of these small travelers show up for an instant along the coast, only to press on to their breeding grounds in the northern reaches of the United States and Canada.

Yet if nature has a quilt, in the Atchafalaya Basin, it must be the Spanish moss that drapes from the bald cypress and water oaks. And if there is a bird that appreciates such a blanket, it's the northern parula.

As they dart from limb to limb between the thick layers of moss—once used after drying to make saddle blankets and stuffing for upholstery and mattresses—over the years, I've watched many of the diminutive pale-blue birds check out this bayou-side real estate. Its nasally *zeeee* sound seemed to always imply it was satisfied with the locale and its abundance of available groceries and nesting places.

These spirited birds arrive during the earliest part of spring and, in the days to follow, will construct and suspend their nests, cloaking them in the safety of the moss.

A neotropical songbird, the parula begins to arrive in late February and early March. But soon to follow are other species of all different sizes and colors, like the prothonotary warbler. Not since Christmas have the trees in our neighborhoods and the surrounding countryside seen such ornamental decorations.

In George H. Lowery Jr.'s third edition of *Louisiana Birds*, he wrote:

> *The title Prothonotary possesses the same high degree of distinction and appropriateness that we recognize in the name of the Northern Cardinal. For centuries of ecclesiastical history, the prothonotary, who is legal advisor to the pope, has worn yellow vestments, as the cardinals have worn red.*

The first arrivals of the year are only a trickle of what's to come following the first days of spring, well into late April, according to John Arvin, retired research coordinator for the Gulf Coast Bird Observatory. Since the early 1970s, much of Arvin's research work involved looking at a radar screen, studying the annual bird migration. Most of the radar interpretation that he did was studying trans-gulf migrants, which depart the southern edge of the Gulf of Mexico in Latin America, head north at dusk one evening and then arrive on the other side sometime the next day.

Arvin credits New Orleans native Dr. Sidney Gauthreaux, from whom he learned, as the father of radar ornithology. Depending on weather conditions, if birds have a strong tailwind and leave one afternoon, Arvin asserted they may reach the northern Gulf of Mexico coastline as early as eight o'clock the next morning.

If the winds are lighter, or if they don't have a tailwind, it might take much longer. And if there is a headwind, the arrival may be long delayed. There is a real possibility they could be in the air twenty-four to thirty-six hours before making landfall.

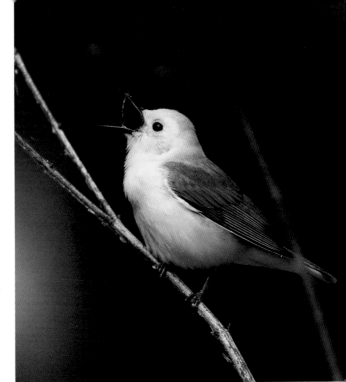

Right: Prothonotary warbler.

Below: Northern cardinals are common throughout the eastern two-thirds of the United States and are a favorite among birdwatchers.

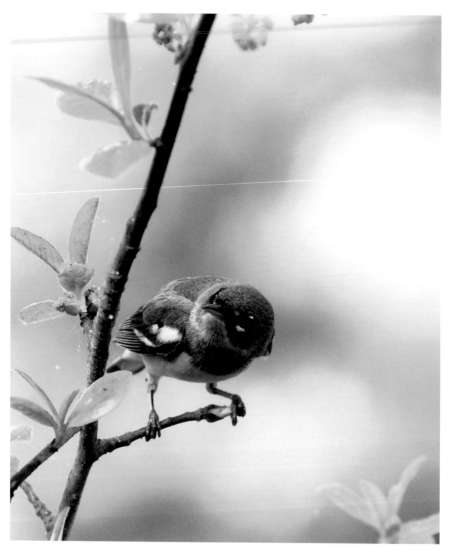

Northern parula.

The northern parula is not much more than four and a half inches in length. Other species, such as warblers, buntings and grosbeaks, are only moderately bigger, making it virtually impossible to see a single bird, which has absolutely no signature on a radar screen.

What Arvin and researchers see during the migration is no fewer than thousands of birds in flight. "Thousands easily," said Arvin. "Late in the season toward the peak, it can be hundreds of thousands. I don't know

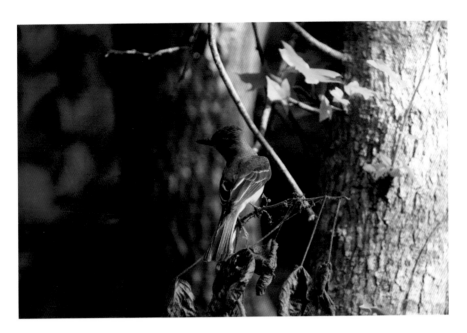

Great-crested flycatcher.

how to quantify the limit when you start seeing birds. You obviously can't see one—even one large bird. So, you have to have reasonable numbers to provide enough reflection to be decisive on the screen."

Wave after wave they come, these cosmopolitans. Painted and indigo buntings; rose-breasted and blue grosbeaks; Baltimore, Bullock's and orchard orioles; flycatchers; tanagers; and warblers all come—with enough colors among them that they could be chips inside a kaleidoscope.

Yet with all of their beauty, birds also are conspicuous standard-bearers for the environment. The study of them is a way of taking nature's pulse. Amphibians and mammals are seen far less than birds and don't provide an obvious subject for determining the health of our environment.

Louisiana is considered one of the top five states for birdwatching. And there may not be a better region in the entire state than the central location of Acadiana to enjoy the migration. To see shorebirds such as black-necked stilts, willets and plovers, one can drive two hours west and arrive at Rockefeller Wildlife Refuge, Lacassine NWR or Sabine NWR, as well as rice fields and flooded crawfish ponds, which attract many of these species.

In two to three hours from Lafayette, travelers can take State Highway 14 from Highway 90/I-49 corridor to highway L.A. 82 south from Abbeville, Louisiana, along the Creole Nature Trail to Rockefeller Refuge and on

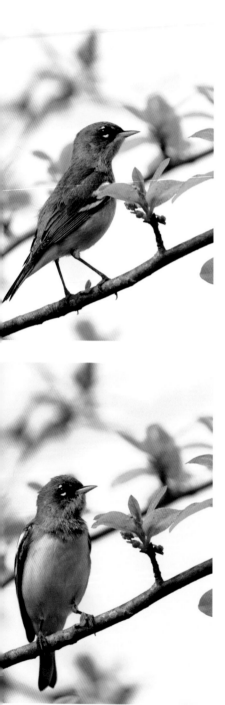

to Rutherford Beach. Both are hotspots for birdwatchers, and Rutherford Beach is a great location for visitors who enjoy shelling as well.

From Rutherford Beach west, birdwatchers and nature lovers can take L.A. 27 to the Cameron jetties to see a plethora of shorebirds. By retracing your route, taking highway L.A. 27 north to the L.A. 82 junction, farther west along 82 is Holly Beach and Peveto Woods Bird and Butterfly Sanctuary.

Retracing the route eastward on L.A. 82 and by taking L.A. 27 northward on the west side of Calcasieu Lake, visitors will pass through Sabine National Wildlife Refuge, where there is no shortage of birds, reptiles and mammals to see.

In central Louisiana, east of and approximately one hour's drive from Lafayette, is St. Mary Parish. The parish is home to Bayou Teche National Wildlife Refuge, which is made up of five separate land units. Bayou Teche NWR is the only U.S. Fish and Wildlife Service (USF&WS) refuge dedicated to the reestablishment of the endangered Louisiana black bear.

In the Garden City Unit, a walk along the Palmetto Hiking Trail, which is located just off the south service road that parallels the Highway 90/ I-49 corridor, will reveal hooded warblers, painted buntings and

Find a tree draped in Spanish moss and you'll find northern parula flitting about. Its slate-blue, yellow, rusty-orange and olive colors make it a spectacle to behold—if it only stayed still for a moment.

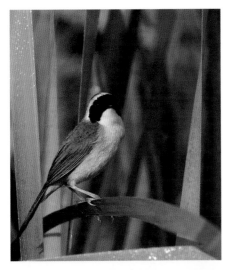

When no other bird sings, the affable common yellowthroat can be heard.

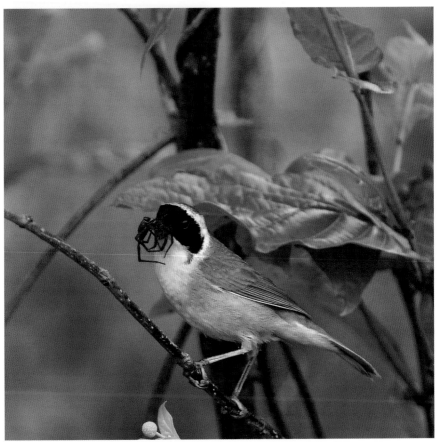

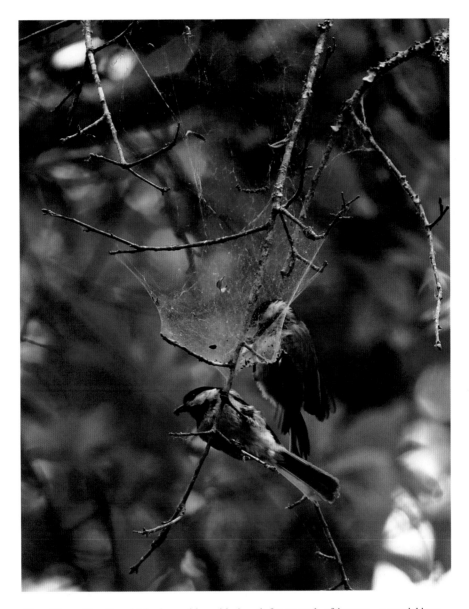

Above: These Carolina chickadees raid a spider's web for morsels of insects—easy pickings for the tiny, agile birds.

Opposite, top: The tiny eastern phoebe is another visitor along the bayou.

Opposite, bottom: Common yellowthroat.

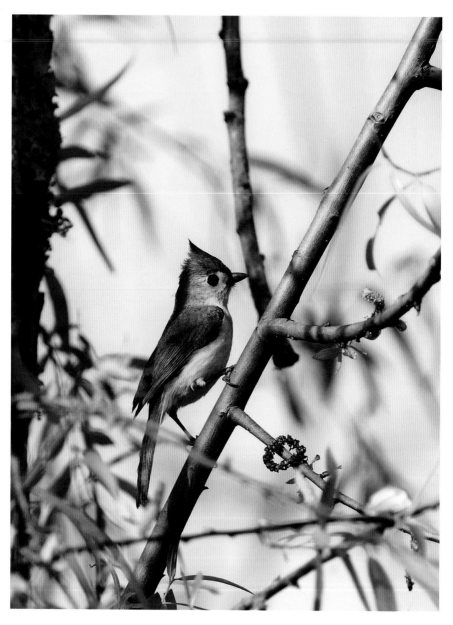

The tufted titmouse's call is a steady "peter-peter-peter" sound. It's often found darting along the edges of swamp hardwoods feeding.

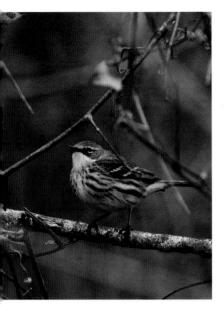

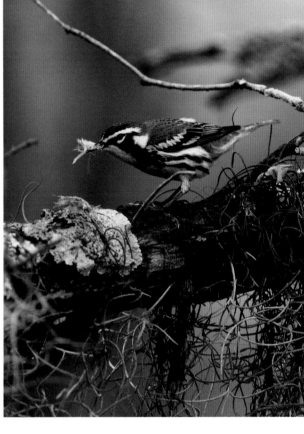

Above: A common winter visitor, the yellow-rumped warbler feeds heavily in the myrtles along the coastline.

Right: Yellow-throated warblers stay busy in the cypress swamps for birdwatchers to see. The slate-gray, black and white colors, offset by a rich yellow throat, make this warbler unmistakable.

indigo buntings, prothonotary warblers, northern cardinals, yellow-billed cuckoos, common yellowthroats, northern parulas and great-crested flycatchers.

The service road will take you farther east, where it will meet Alice C Road. Alice C Road will take you to a refuge boardwalk, and it's here I've seen barred owls, Carolina chickadees, yellow-throated warblers, red-bellied woodpeckers, pileated woodpeckers and both downy and hairy woodpeckers. The prize of this particular location, if you're lucky enough to see one, is the swallow-tailed kite.

The swallow-tailed kite often appears suddenly near the boardwalk, as if it were a ghost. With a wingspan of approximately four feet, twice its body length, it is a large bird, but perhaps no large raptor is as graceful and agile

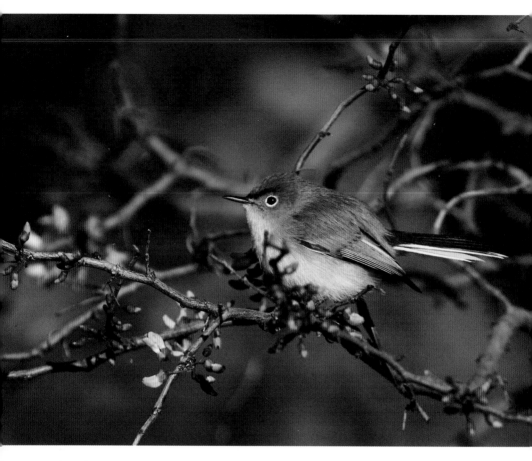

Above: Blue-gray gnatcatcher.

Opposite: The yellow-billed cuckoo is a reclusive bird that skulks through the trees and thickets along the bayou.

in flight. It has a white head and underbody that is striking against its black back and tail. After observing one for the first time, no one ever forgets the experience.

Once again, using Lafayette as your central location, an approximate two-hour drive from this city traveling Interstates I-10 and I-12 will take you north of Lake Ponchartrain to Mandeville and Fontainebleau State Park. Here you'll see similar birds as those found on Bayou Teche NWR. But, in truth, any drive along a country road north, south, east and west of Acadiana during April and May will reveal beautiful birds, particularly if you happen to find a live oak covered in Spanish moss or early successional habitat.

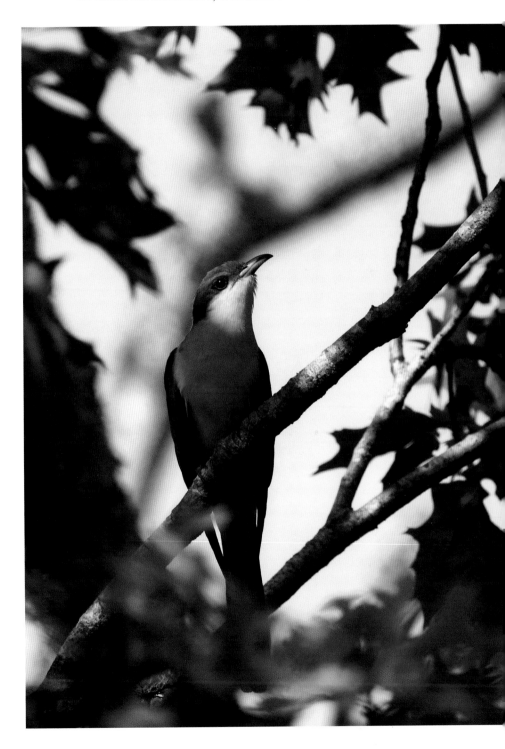

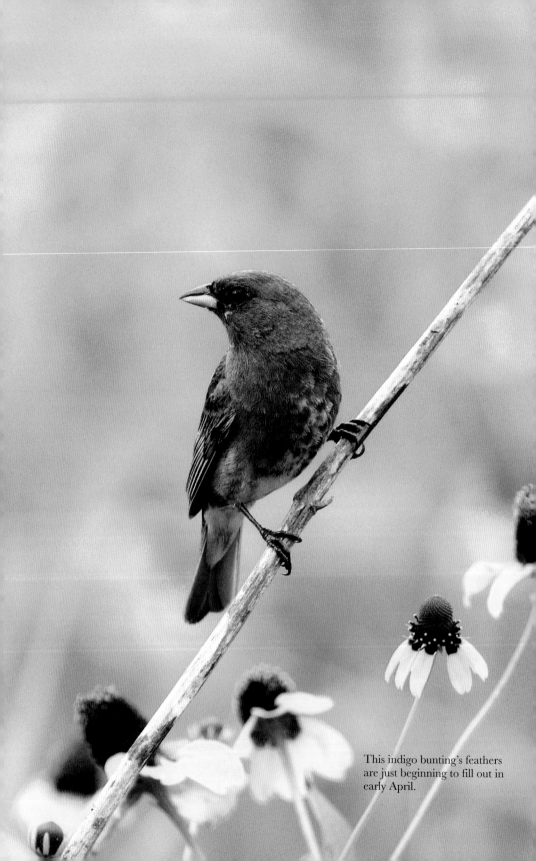

This indigo bunting's feathers are just beginning to fill out in early April.

Moreover, you just might see northern parulas, prothonotary warblers and numerous other neotropic songbirds darting limb to limb.

Bird size and wingspan can be as diverse as the color of their feathers. From pint-size warblers to prodigious raptors such as the swallow-tailed kites, they are big and small. Each species has its own unique survival traits and associated space in the habitat it uses. The birds along the bayou both share and avoid one another in the territory. Essentially, a study of birds is a study of their habitat, too.

TABLE 1

TYPICAL WARBLER, BUNTING, WOODPECKER AND SWALLOW-TAILED KITE
SIZE COMPARISON

Species	Size in Length	Wing Span
Yellow-throated Warbler	5.5"	8"
Yellow-rumped Warbler	5.5"	9.5"
Prothonotary Warbler	5.5"	8.75"
Common Yellow-throat	5"	6.75"
Hooded Warbler	5.25"	7"
Painted Bunting	5.5"	8.75"
Indigo Bunting	5.5"	8"
Downy Woodpecker	5.5"–7.1"	9.8"–12.2"
Hairy Woodpecker	7.1"–10.2"	13"–17"
Red-bellied Woodpecker	9"–10.5"	15"–18"
Pileated Woodpecker	15.8"–19.3"	26"–29.5"
Swallow-tailed Kite	20"–25"	46"–48"

March through May is the prime time to enjoy birdwatching in Louisiana. And perhaps there is no better time to enjoy the Atchafalaya Basin. The basin's alluring beauty rests on the doorstep of Acadiana, where each spring sunrise brings a symphony and majestic display for all to see.

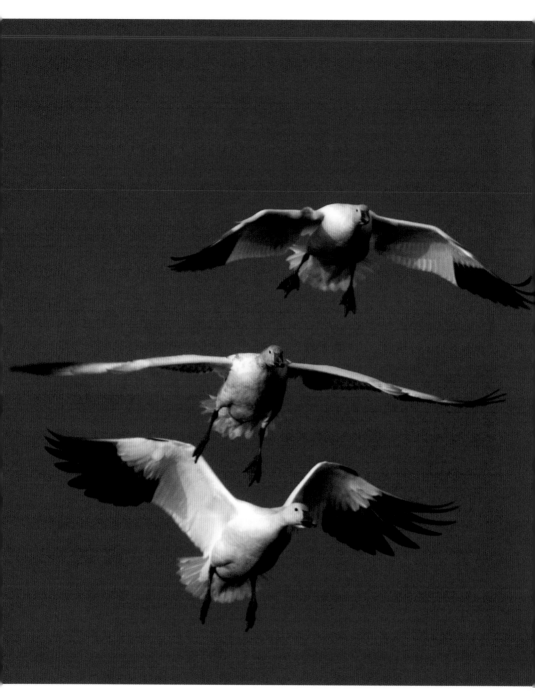

Snow geese descending on their wintering grounds in southwest Louisiana.

WINTERTIME SNOW GOOSE ADVENTURE

Somewhere between 2:00 and 3:00 a.m. one winter I was dreaming of a white Christmas with the music of Dean Martin singing in the background, "Let it snow—let it snow—let it snow," when suddenly the alarm went off.

Jumping to my feet, I went to my wife Christine's side of the bed and gently said, "Wake up, honey, it's time to go."

"Nooooo," she sleepily replied. "It's too early."

"You can bring your blanket and pillow and sleep in the car while I'm driving," I softly implored.

"Okay, but if I'm grouchy, you have to be patient with me," was her answer. And in that instant, we were out of the house and on the highway.

Though it seems a bit crazy to be up at that time of morning in the middle of winter in Louisiana, it wasn't the blustery snow of a Colorado ski resort that I dreamed and was anxious about. It was flocks of snow geese so thick they resembled the snowflakes falling on Breckinridge during a whiteout.

Our destination? Cameron Prairie National Wildlife Refuge, more specifically, Pintail Drive, with cameras in hand—a three-hour drive.

Cameron Prairie NWR is a 9,621-acre refuge consisting of marsh, coastal prairie and agricultural rice fields (a.k.a. moist soil units by the USF&WS) that are important habitats, not only for migratory waterfowl but also numerous species of birds and other wildlife that use them throughout the year. The refuge offers recreational hunting and fishing in addition to providing excellent non-consumptive opportunities such as birding and nature viewing.

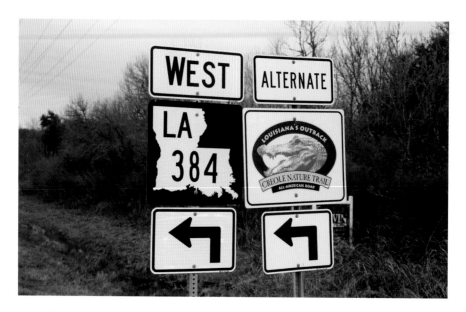

Above: The Creole Nature Trail, known as Louisiana's Outback, covers 180 miles of state highways in the remote regions of southwest Louisiana.

Opposite, top: The photography blind Cameron Prairie NWR.

Opposite, bottom: Photography blinds can offer spectacular sunrise views besides nature.

The refuge is part of the 180-mile Creole Nature Trail, also known as the Louisiana Outback. What's more, this stretch of Louisiana highway is only minutes away from Lake Charles, a short ninety-minute drive from Lafayette, three hours from Houston to the west and three and a half hours from New Orleans to the east. The Creole Nature Trail will take nature lovers on a journey of exciting intrigue, should wildlife drive their impulses like it does many.

Once I got the first gas station cup of cappuccino into my bride, she was up for the duration. And not once was she ever grouchy.

Arriving at Pintail Drive in the dark was all part of my plan to have us settled inside a refuge photography blind located over a grit pond. Essentially, snow geese have a fairly habitual respite following their migratory trek to the Gulf of Mexico coastline for the winter. They need food resources and grit in the form of sand or small pebbles for their gizzards, plus water to digest their food. And they also need a place to rest and preen throughout the day.

Much of southwestern Louisiana offers all of these things, as the agricultural rice fields are within a few short miles of the coastal open bay

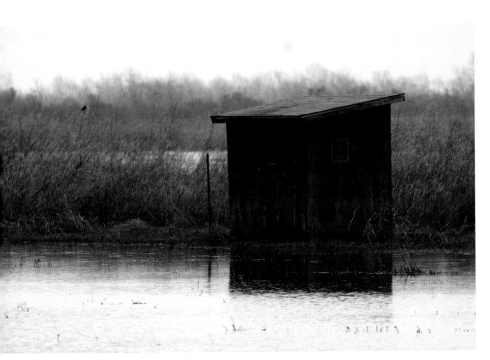

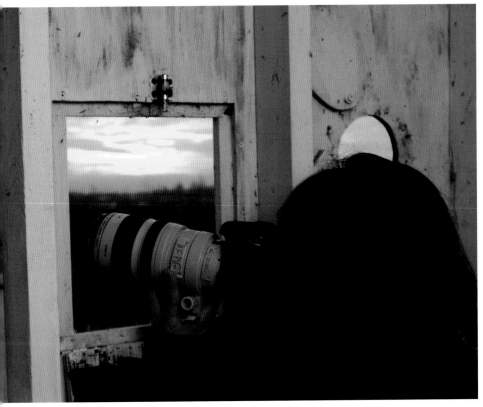

estuaries, where there is plenty of sand for them. Theirs is a quotidian lifestyle much of the winter, save for a few sentries that are always on alert for predators.

The blind on Pintail Drive is available on a first-come, first-served basis for viewing snow geese and waterfowl. The little wooden photography shack is roomy enough for three to four people. It has several small cutouts large enough for most telephoto lens covers to fit through. They also are strategically located to provide and offer ample opportunity for nature viewers and photographers to see wildlife up close. Geese will typically arrive within an hour after sunrise. But from daylight on, there usually is never a dull moment on the grit pond, as waterfowl, gallinules and wading birds show up in droves.

Though snow geese arrive in Louisiana in early November, the large, massive bodies don't typically arrive in the region until mid-December. But once they do, they usually show up almost every day on Pintail Drive to pick up sand and grit. What's more, they'll be in the area for a couple of months through late February. However, sometimes it's best to call the refuge headquarters first before you make the drive to this remote part of the state. Refuge staff usually pass by the grit pond daily and can tell you if the birds are present there or not—moreover, if they are, at what time.

To see a huge flock of snow geese rise off of a field because of a disturbance or their own accord is nothing less than a natural marvel. Their initial ascent looks like raucous chaos before they organize in flight into the familiar V-shaped formations.

When they arrive at their destination, the chaos has become more orderly. Their descent is much like that of a major airport with air traffic controllers. Above the field, they circle as individual family groups land until the field looks as if it's covered in snow.

Snow geese travel over three thousand miles from their breeding grounds in the far reaches of northern Canada to the Gulf Coast. They have voracious appetites; a large flock will reduce a pond's subaquatic vegetation to nothing in short order. They are not picky eaters and often spend over half of the day foraging. They are completely vegetarian and will eat grasses, sedges, forbs, tubers, grain and new-growth agricultural crops like winter wheat.

There are several places to see massive bodies of snow geese during the winter in southwest Louisiana besides Cameron Prairie NWR. There is also Lacassine NWR. By taking L.A. 27 south from Lake Charles and east on L.A. 14 to Illinois Plant Road south, you'll arrive at the Lacassine

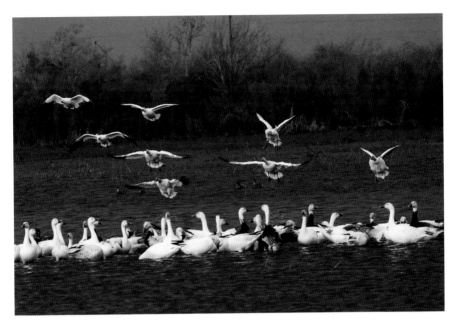

Snow geese descend on a pit.

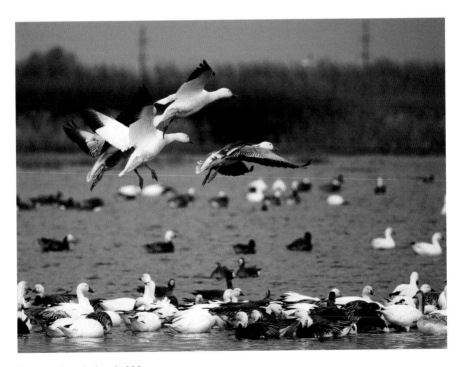

Snow and eagle-headed blue geese.

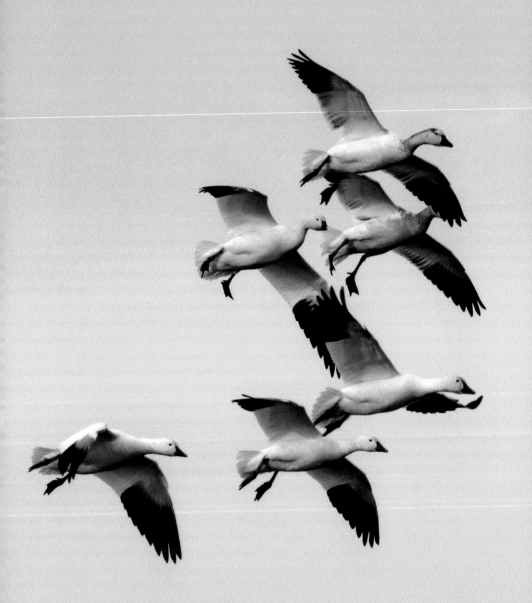

Snow geese number in the tens of thousands during the winter in southwest Louisiana.

NWR Pool Unit, where you'll have an opportunity to see snow geese and other waterfowl.

Just a couple miles farther east along L.A. 14 you'll come to L.A. 99. Along this rural road north, toward the town of Welch, you can see flocks of snow geese bodied up, resting and feeding in the agricultural fields. Continuing east along L.A. 14 you'll come to the town of Gueydan. A drive through any of the surrounding rural roads like Marie Michel Road or L.A. 91 south, toward White Lake Conservation Area, will also produce geese to observe.

Farther east along L.A. 14 will take you to the town of Kaplan, where it meets the L.A. 35 junction south. By taking L.A. 35 south to the junction of L.A .82 it's approximately a one hour drive to Grand Chenier and Rockefeller Wildlife Refuge.

Rockefeller Refuge is a seventy-one-thousand-acre birdwatcher's dream dedicated to wildlife, fisheries and wetlands research. The refuge is known to overwinter a population of over 160,000 waterfowl, including snow geese.

Snow geese also frequent agricultural regions in the northern part of the state. However, flocks are typically not as concentrated as they are in southwest Louisiana.

Cameron Prairie NWR also is host to a joint effort between the United States Geological Survey, University of Georgia–Athens, Louisiana Department of Wildlife and Fisheries and United States Fish & Wildlife Service, which conduct scientific research through bloodletting and banding efforts studying the intercontinental dispersal of infectious agents such as viruses and parasites. Snow geese travel thousands of miles between their breeding and nesting grounds and pass through three countries: Canada, the United States and Mexico.

Cameron Prairie's Pintail Drive is 3.1 miles long. In addition to snow geese, white-fronted geese also utilize the grit pond along with numerous species of puddle ducks. Those species include pintails, mallards, blue-winged teal, green-winged teal, an occasional cinnamon teal, northern shovelers and gadwalls.

There also are plenty of wading birds to see, such as white-faced ibis, great blue herons, great egrets, snowy egrets, tri-colored herons, little blue herons, yellow-crowned night-herons and roseate spoonbills, that make this refuge home for the winter.

There is opportunity to see white pelicans down from the upper Midwest, black-necked stilts during the late fall and following spring and plenty of white ibis. Other birds you'll find along Pintail Drive are grebes, common moorhens, coots, various rails, cormorants and raptors.

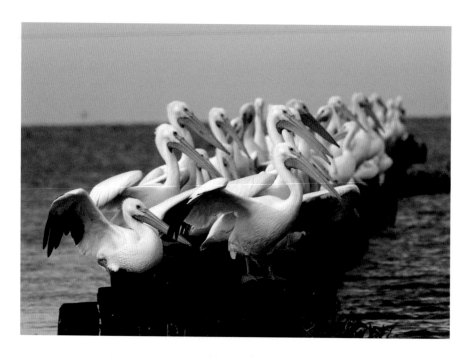

Above: Louisiana has a long list of wading birds that walk the shallow waters of bayous, ponds, lakes, bays and flooded rice fields. The tri-colored heron, also known as the Louisiana heron, makes a living in all of these habitats.

Opposite, top: White pelicans are winter residents of coastal Louisiana regularly seen along the bayou.

Opposite, bottom: Spectacular rich hues of blue and deep purple make the little blue egret a favorite wading bird of the wetlands.

Once in the blind, Christine and I watched a spectacular sunrise together waiting for the geese to show up. Nature lovers should know that refuge rules require you to stay in the blind until the snow geese leave, which in some cases could be a few hours, so as not to disturb them or change their routines.

Louisiana's climate is considered subtropical, but that doesn't mean winters in this state aren't cold. On the contrary, the average high is sixty degrees Fahrenheit during the months of December and January and average low of forty-four Fahrenheit. The two weeks between Christmas and New

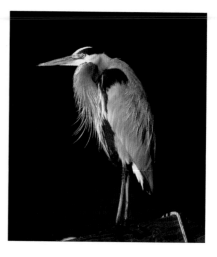

Great blue herons are common wading birds along the bayou. *Photo by Christine Flores.*

Year's 2017–18 saw daytime high temperatures in the thirties and overnight lows in the teens. It can be uncomfortably cold when arriving before daylight and then sitting for several hours in the photography blind.

The 2017–18 Louisiana winter also saw snow come to the region twice during the solstice period before Christmas. However, Louisiana winters can be wet, humid and foggy. Visitors need to consider what type of clothing to wear in order to be comfortable.

Rain gear, knee boots, base layers, neck gaiters, beanie caps, windbreakers and a heavy overcoat should all accompany birdwatchers and nature viewers anywhere along the coastline during Louisiana winters—it's commonplace for out-of-towners to underestimate conditions.

For Christine and me, birdwatching and nature viewing always includes eating somewhere afterwards.

The comforts of wood burning in the fireplace at the Regatta Seafood & Steakhouse in Lake Arthur—thirty minutes east of Cameron Prairie—capped off our snowbird adventure on the coastal prairie. And as we warmed ourselves next to the fire together, we daydreamed of angelic snow geese landing before us.

I'm almost sure someone heard me humming, "Let it snow, let it snow, let it snow."

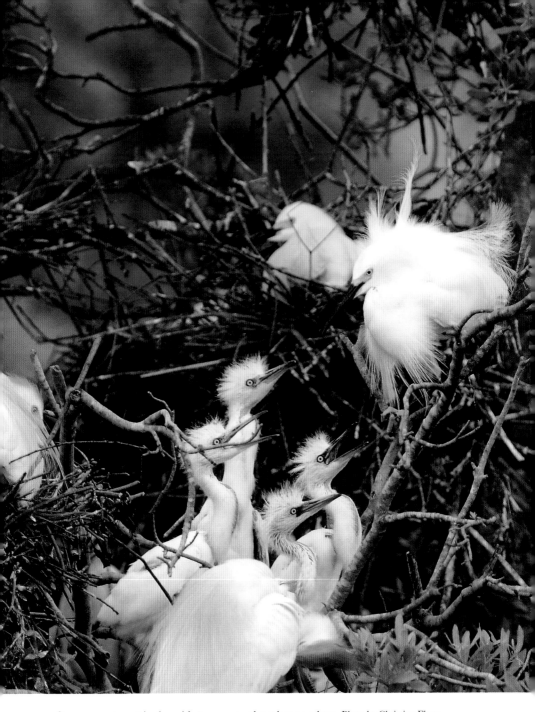

Snowy egrets nest in the mid-story cover along bayou edges. *Photo by Christine Flores.*

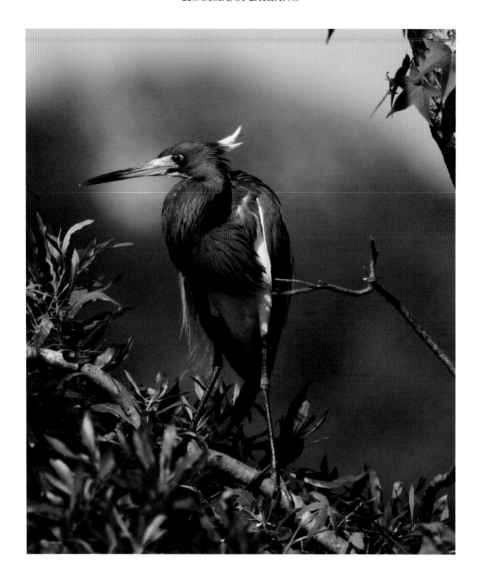

SNOW GOOSE NOTABLES

Adult snow geese typically are twenty-eight inches in total length with an approximate wingspan of fifty-three overall. This species of goose has two color morphs, white and dark. The white morph has black wing tips, a pink bill and pink legs.

The dark morph snow goose has striking color blends of slate grays and blacks on its back and underwings. Adults, known as blue geese, often have

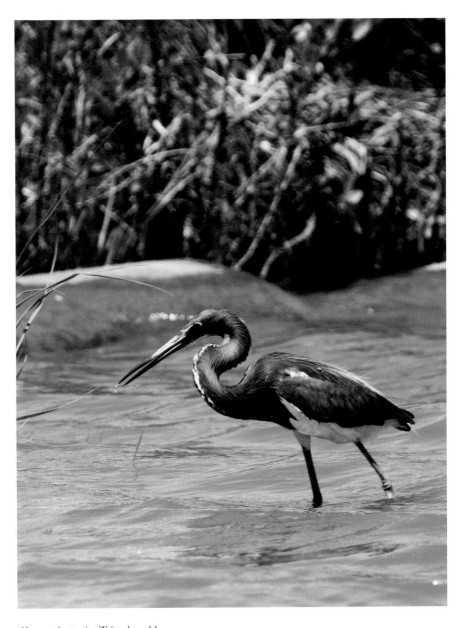

Above and opposite: Tri-colored herons.

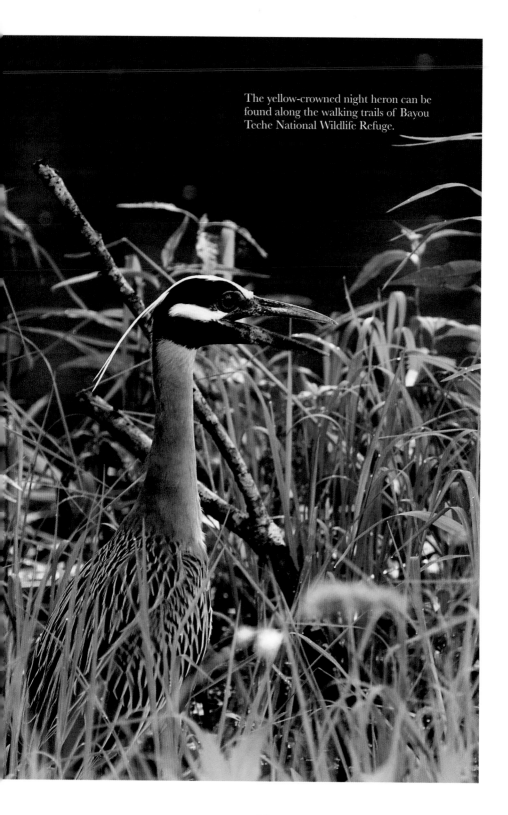

The yellow-crowned night heron can be found along the walking trails of Bayou Teche National Wildlife Refuge.

beautiful white heads and are nicknamed "eagle heads." Because of this, they are highly prized by hunters.

In the Mississippi Flyway, snow geese migrate from their tundra nesting grounds to winter mainly in Arkansas, Louisiana and Texas, near agricultural areas. The southwest Louisiana agricultural rice fields are prime locations to observe them during winters, where it's not uncommon to see massive flocks of ten thousand or more.

The sheer volume of a rising flock can be deafening up close and something that will leave an everlasting impression on anyone who has the opportunity to experience it.

Snow and blue goose populations have grown exponentially since the 1970s, and overpopulation has been a serious concern with wildlife agencies in the United States and Canada for the past two decades. Reasons for the increases appear to be agricultural practices, as waste grain is readily available along their migratory routes; their survivorship, as snow geese live upward of twenty years; and possibly even climate change, as winters have been less severe of late, allowing for increased productivity of nesting pairs.

The snow goose population is currently stable and estimated at somewhere between four and a half and five million. It is growing at a rate of approximately 5 percent per year.

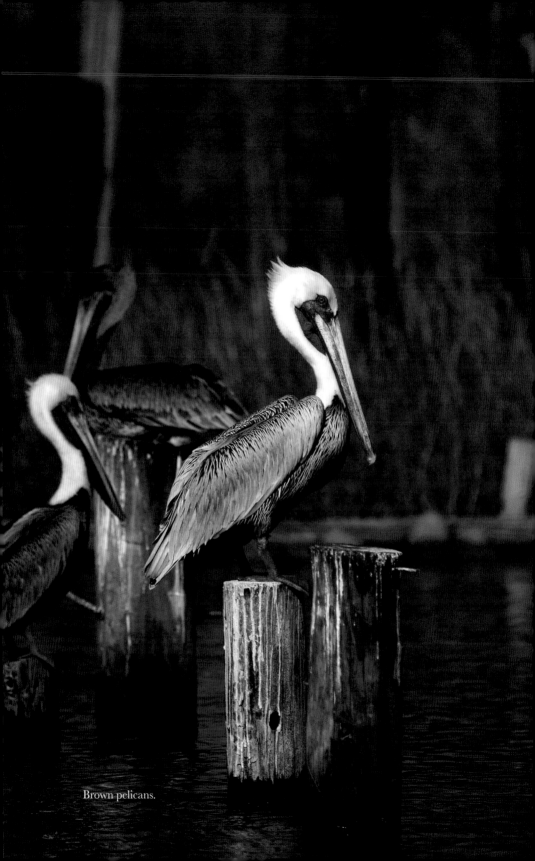
Brown pelicans.

THE TRANSLOCATION OF ENDANGERED BROWN PELICANS

Many bayous along the Louisiana coastline open into shallow bays to form brackish water estuaries. The brown pelican, once totally extinct throughout the state, was removed from the Endangered Species List in 2009 by the U.S. Fish and Wildlife Service. The brown pelican's remarkable recovery has been so successful, few pylons are passed along waterways that do not have one perched on them. No one would argue that today this iconic friendly bird along the bayou is a favorite of many.

Squawking—screaming in protest—a young brown pelican was safely held in the trained hands of University of Louisiana–Lafayette graduate student Kyle Patton. The year was 2007, and Patton had just captured another fledgling for banding and tagging on Last Island.

The brown pelican was listed as endangered by the U.S. Fish and Wildlife Service on October 13, 1970. Over the course of the next forty years, national efforts extending from Florida along the Gulf Coast to Texas and westward to California were made to protect, preserve and, where possible, translocate the emblematic bird, also recognized as Louisiana's state bird.

Six projects were funded by a USF&WS grant following the devastating destruction of Hurricanes Katrina and Rita in 2005. The two storms ravaged the Louisiana coastline, causing catastrophic damage and habitat loss. Several brown pelican colonies were lost due to the scouring wave

action along the beaches. The storms reduced the brown pelicans' nesting potential through erosion and land loss.

Following the storms, LDWF personnel assisted in the translocation of 112 brown pelican fledglings from Last (a.k.a. Raccoon) Island to Whiskey Island along the Louisiana coast, south of the fishing village of Cocodrie. The relocation project was 100 percent funded by federal dollars.

According to biologist Mike Carloss, who at the time was the LDWF Coastal Operations Program manager, the pelican research-translocation project grant application, at $200,000, was one of the largest requested projects following the 2005 hurricanes.

As a result of natural disasters, particularly hurricanes, loss of habitat, DDT and other related pesticides such as edrin, the endangered brown pelican became extinct in Louisiana during the early 1960s. It was during the late sixties and early seventies that joint restocking efforts between the Florida Game and Fresh Water Fish Commission and the LDWF led to populations being reestablished on several islands along the southeastern Louisiana coastline.

The LDWF was involved in the original relocations from 1968 to 1976, where approximately 767 brown pelican chicks were captured from Florida's Atlantic coast and relocated to Queen Bess Island and Rockefeller Wildlife Refuge to reestablish brown pelican populations. In 1971, the first brown pelicans nested on Queen Bess, where 11 nests fledged 8 birds. By 1989 there were 600 pelican nests that raised 800 young.

The current statewide estimated population of brown pelicans is 80,000 to 100,000. It was clear, the department had some of the know-how to complete the post Katrina and Rita project.

Carloss said the department came to the table following the disastrous storms indicating the multiyear project was something they'd like to do and take the lead on. In 2007, with funding in hand, a collective effort between the USF&WS, LDWF and the University of Louisiana–Lafayette began to move the project forward.

Initially, one of the project goals was to translocate the fledgling pelicans and feed them for several weeks until they could feed on their own. However, the biologists were surprised at how quickly the birds adapted.

Carloss, in describing the effort, said, "They seemed to feed on their own early on—they seemed to have that instinct—we assumed anyway. One day out of eighteen they actively fed and seemed like they did it more out of competition, but I never once saw where they were overly hungry."

Another goal the biologists planned to achieve as part of the translocation project was to band and tag five hundred pelicans to track their movement island to island. Fledgling birds were banded at nine to ten weeks old by University of Louisiana–Lafayette doctoral student Scott Walter.

Walter pointed out that brown pelicans typically don't stray too far from where they fledge, indicating there was a good chance they would return to their relocated islands. The study's idea was that if department officials could spread them out and they came back and nested, they were relatively sure the chicks would return in the future.

During the brown pelican relocation process, as with handling all wildlife, every effort and care was taken by the biologists and volunteers not to stress or harm captured pelicans. Kyle Patton, at the time a UL–Lafayette graduate student, grew up one mile from the campus and volunteered to help Walter. Patton's father was a birdwatcher.

In describing his particular strategy on handling the pelicans, Patton recounted how he would leave a finger between the pelicans' bills when he held them in order to not block off their ability to breathe.

Patton noted that he had seen people hold pelicans by their necks and how dangerous that could be for the birds. He stressed the best way to hold them

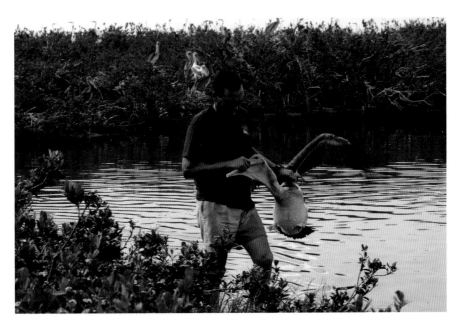

Mike Carloss catches and brings a brown pelican to be tagged and banded.

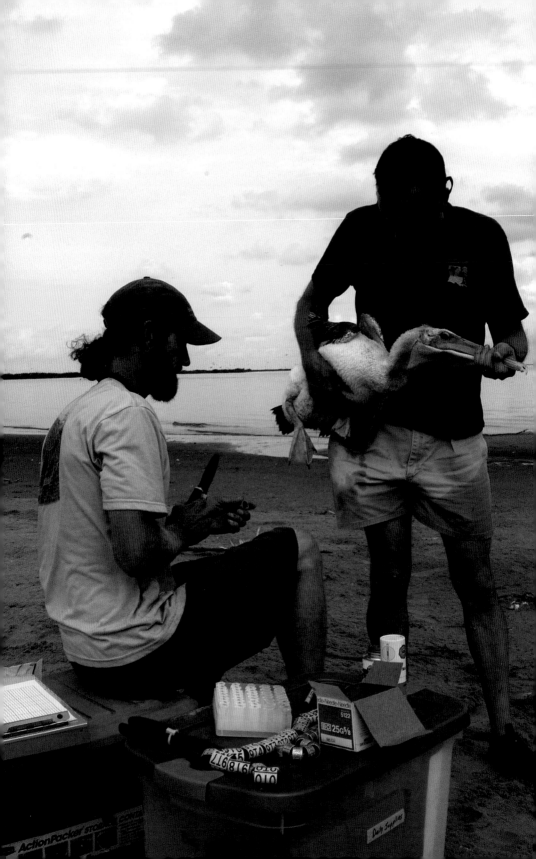

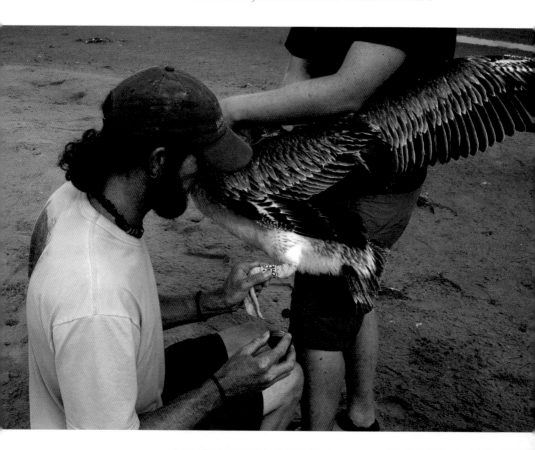

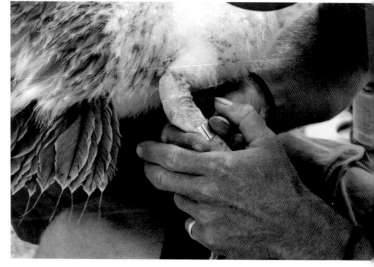

Above: Scott Walter, a University of Louisiana PhD student, bands and tags a brown pelican.

Right: Pelican banding.

Opposite: Louisiana Department of Wildlife and Fisheries Coastal Operations manager Mike Carloss (*holding pelican*) assists Scott Walter with banding and relocation efforts on Whiskey Island.

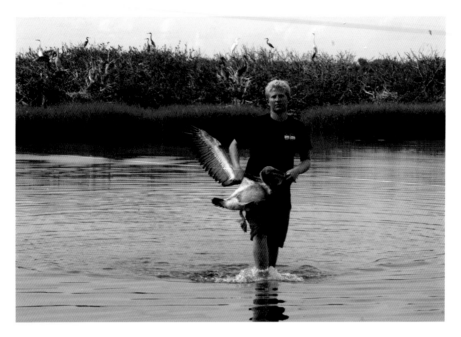

Kyle Patton, a University of Louisiana graduate student, helps capture a juvenile brown pelican to be banded.

was to prevent, if at all possible, the pelican's neck from turning, keeping the bird from possibly losing air.

In 2007, with an estimated 3,600 nesting pairs located on Last Island at the time, the pelicans had been reluctant to seek other areas to nest. To this day, coastal erosion continues to be a problem throughout much of Louisiana.

A few noteworthy facts concerning wetland loss in the state:

- 30 percent of all U.S. coastal marsh is located in Louisiana.
- 90 percent of coastal wetland loss in the lower forty-eight states occurs in Louisiana.
- And 95 percent of the marine species in the Gulf of Mexico spend all or part of their lifecycles in Louisiana's wetlands.

Carloss pointed out much of Louisiana's brown pelican population was nesting on marginal habitat. He speculated that's because it was all that was left. "Instead of on their own moving to another island that has better habitat—like Whiskey Island—they would rather stay on their old traditional grounds and nest," Carloss theorized.

The brown pelican's scientific name is *Pelecanus occidentalis*. It differs from its cousin not only in the obvious color and size but also in the way it forages. White pelicans work as a group, essentially rounding up fish, whereas brown pelicans dive for their food.

It's not uncommon to find brown pelicans following shrimp boats and other fishing vessels as they toss their bi-catch overboard. Often, commercial vessels' propellers will churn up the water, causing fish to rise to the surface. Brown pelicans will dive from as high as sixty-five feet, thrusting themselves straight as arrows below the surface.

Brown pelicans are opportunistic feeders, too. Many photographers have gone to a dock or bayou bank and tossed pogies into the water where brown pelicans will dive for them. On the birds' way down, the photographer catches the spectacular acrobats in flight and penetrating the surface of the water much like Olympic divers.

Still other brown pelicans notoriously hang around fishing piers with cleaning stations. As scraps of cleaned fish are washed overboard for the blue crabs to eat, invariably, a few brown pelicans with be there to fight over the morsels.

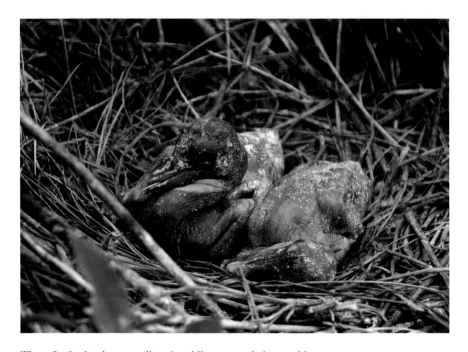

These featherless brown pelican hatchlings are only hours old.

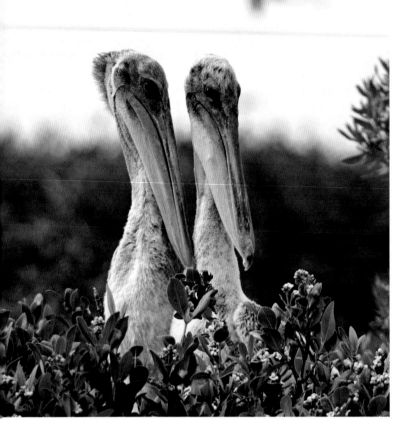

Left: Brown pelicans nest in the mangroves on the barrier islands. Here two brown pelican young waiting for food from their mother share a nest. *Photo by Christine Flores.*

Below: Hundreds of young brown pelicans feed in the shallow water off Whiskey Island.

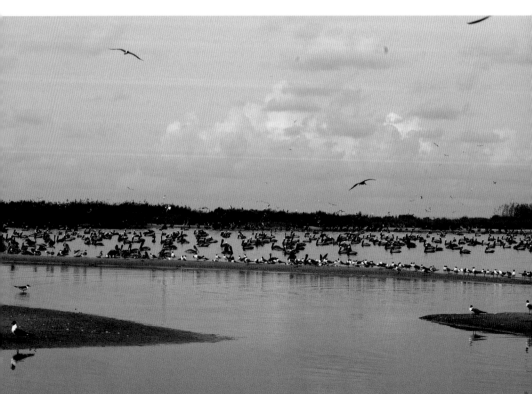

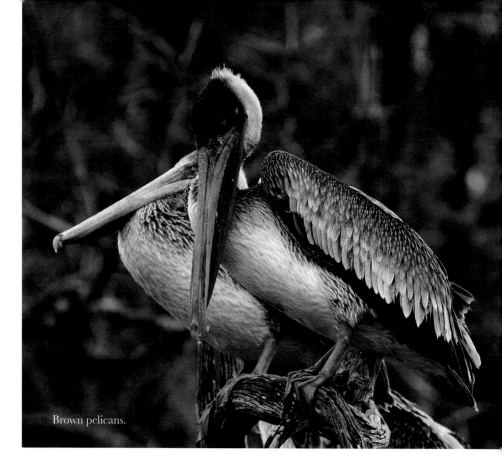
Brown pelicans.

Brown pelicans will typically lay a small clutch of three eggs during the spring. They are colonial nesters, and their nests are above the hide-tide mark and usually found in the mangrove roots along the Louisiana coastline.

The brown pelican's incubation period is twenty-nine to thirty-five days. Following incubation, chicks are born hairless, and it usually takes about ten days for them to get a layer of down on their bodies. Compared to tiny songbirds that fledge their young in a matter of days rather than weeks, brown pelicans fledge their young in approximately twelve weeks.

Brown pelicans nest on estuary islands to avoid predators. Nevertheless, only 30 percent survive their first year of life, and as little as 2 percent live longer than ten years. The longest recorded lifespan of a brown pelican is considered to be forty-three years.

Though brown pelicans were removed from the endangered species list in 2009, they still live with potential threats that could impact their populations. Hurricanes are still a serious hazard throughout the summer and can have grave consequences to pelican numbers. Other dangers

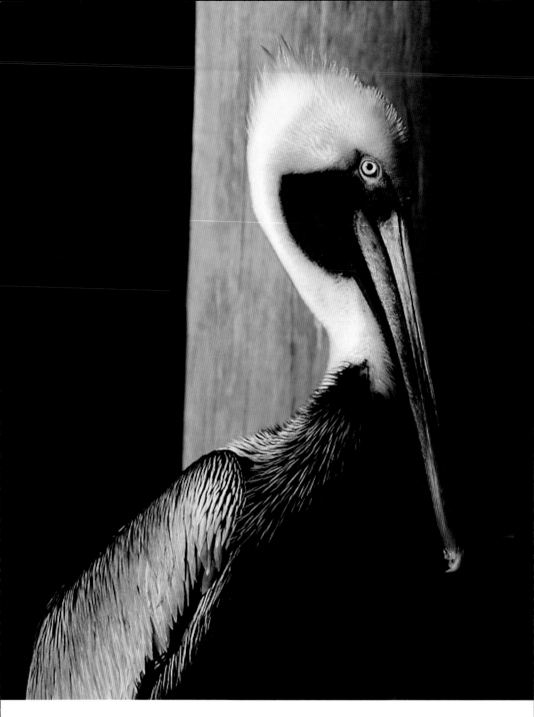

From extinct to flourishing, the state bird is as common today along the coast as sparrows are in most backyards. The brown pelican's comeback is extraordinary to say the least. *Photo by Christine Flores*.

include avian botulism and manmade problems such as the control of pesticide use and oil spills from offshore energy production.

Since 1912, the pelican has graced the Louisiana state flag above the words "Union, Justice and Confidence." This iconic bird will continue to be a common sight along the state's coastline as a result of the many translocation projects and research following the ravages of storms, pesticides and wetland loss in years past. In 2009, its delisting demonstrated the dedication and diligence of the wildlife community to restore this species of bird.

Final Note

Three years after the 2007 brown pelican relocation project and one year following delisting as an endangered species, eleven people were killed and seventeen others were injured as a result of the BP Deepwater Horizon Oil Spill Disaster on April 20, 2010. The oil spill was both a human tragedy and ecological disaster

The manmade catastrophe came at a time when colonial nesting birds were utilizing the Louisiana coastline. Some 205.8 million gallons of oil spilled into the Gulf of Mexico for eighty-seven days until finally being reported, capped and sealed on September 19, 2018.

Brown pelicans were hit extremely hard. Of the 7,258 known bird deaths caused by the spill, 826 were brown pelicans—the second highest in numbers killed. Laughing gulls experienced the greatest losses. Queen Bess Island, the original site of the initial brown pelican relocations, was heavily impacted, and many of the birds nesting on this important rookery were exposed to oil.

In the years following the spill, stricter offshore standards have been implemented to reduce the risks of this type of failure from occurring again. However, the United States and the world continue to use fossil fuels as a primary source of energy. Today, the United States rests at the top as the world's leading producer of petroleum and natural gas hydrocarbons ahead of Russia and Saudi Arabia.

An abstract article published by Proceedings of the National Academy of Sciences of the United States of America (PNAS) titled "Fallout Plume of Submerged Oil from Deepwater Horizon" cites research conducted by David L. Valentine, the chief scientist who conducted federal damage assessment

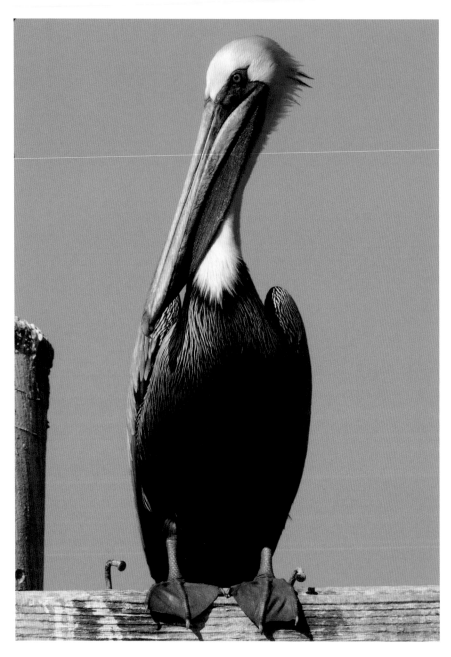

Brown pelican.

on the spill. Valentine is a geochemistry professor at the University of California–Santa Barbara. According to Valentine and his team's report, a "bathtub ring" still remains and is approximately 1,235 square miles in size. The ring formed from an oil-rich layer of water impinging laterally upon the continental slope and a higher-flux "fallout plume" in which suspended oil particles sank to the underlying sediment.

An Associated Press article written by Seth Bernstein in October 2014 compared the bathtub ring in physical size to the state of Rhode Island. In other words, it remains a huge scar on the sea floor of the Gulf of Mexico some forty-three miles from the Louisiana coastline. It is hidden beneath the surface, where no one can see the breadth of the damage.

If this scar occurred on land, would we turn a blind eye to such things? In the years since the disaster, scientists are still trying to determine what the long-term effects will be.

Another question should be, what about our neighbors to the south in Mexico, Central America and South America? The United States, with its vast resources of equipment and services, was incapable of responding to such a catastrophe in short order, and neither were major oil companies. The Gulf of Mexico's loop currents caused oil to move eastward from the spill site, impacting other states' tourism industries along with commercial and recreational fishing the region so depends on.

It is clear that the United States will continue to use hydrocarbons well into the foreseeable future along with growing industrial nations like China and India, not to mention Europe, Russia and other countries around the world.

With so much loss of human life and environmental damage, it is imperative going forward that regulatory policy governing offshore energy exploration and production holds producers to the highest standards possible to ensure another manmade disaster of this magnitude never happens again.

The author reads the number off of the leg band of a laughing gull—a rehabilitated victim of the BP oil spill—he accidentally caught.

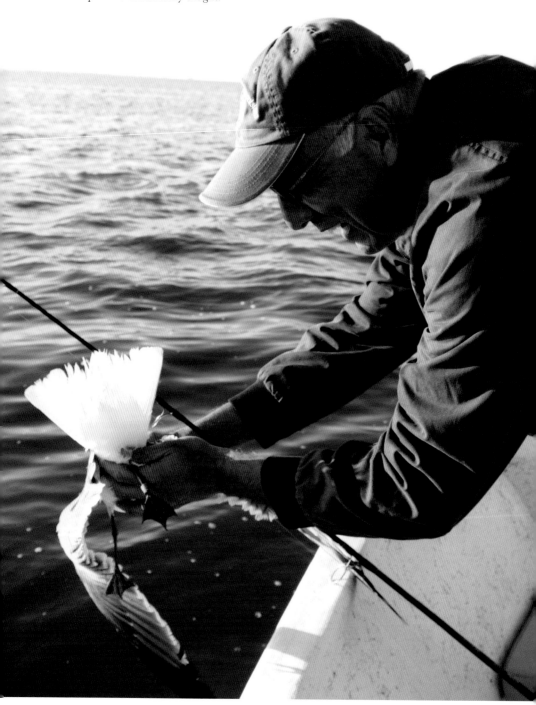

4
0914-51043

What Are the Chances?

Author's note: The April 20, 2010 Deepwater Horizon Oil Spill still has unanswered questions today pertaining to the long-term impact the disaster could have on this region. This story fittingly happened to an outdoor writer and nature photographer.

hat are the chances? Seriously? What are the chances of an outdoor writer who makes thousands of casts, tossing artificial baits at both fresh and saltwater fish, accidentally catching a bird with a band on its leg on April 19, 2012, nearly two years to the exact day that it survived the BP Deepwater Horizon oil spill? If it were anyone else, perhaps it would be considered bad luck. But when it's an outdoor writer, it's fate.

When others in the boat we shared on a fishing trip to Lake Calcasieu were busy catching speckled trout, Gotta-Go Charters fishing guide Captain Sammie Faulk was assisting me with the removal of a treble hook from the leathery part of a laughing gull's leg, just above the band.

Hooking a bird wasn't something those in our group, myself included, tried to do. Using a proven technique, we were all casting in the general direction of a raucous group of hovering gulls feeding on baitfish near the surface of the lake's brackish water—trying to catch speckled trout in a feeding frenzy.

The gull, in grabbing my bait from the water, was doing what comes naturally to it. It was just trying to make a living on the lake. Releasing the bird unharmed would normally have been the end of the story—outside of

some general ribbing from the other anglers related to my skill as a fisherman. I'd have to bear that throughout the day, not to mention enduring the effects of a few red pinch marks from the gull's beak.

While I carefully held the bird, Faulk helped me read the numbers 0914-51043 to one of our other anglers, who wrote them down. Letting the bird go, we watched it fly off no worse for wear. Deep down, something in me instinctively knew that the discovery of this particular band meant there was more story to tell.

Laughing gulls are one of the most common birds found along the coastline. They're like the ubiquitous house sparrow. Additionally, I hadn't heard any scuttlebutt from my biologist friends in the Louisiana Department of Wildlife and Fisheries pertaining to any studies going on banding gulls taking place.

Waterfowl hunters never forget the excitement of harvesting a banded duck. Moreover, they typically place the bands on their call lanyards and wear them with pride around their necks. When a hunter reports the band, he or she will receive a certificate of appreciation that tells them when, where and who banded the bird.

The U.S. Geological Survey (USGS) Bird Banding Laboratory works in cooperation with the U.S. Fish and Wildlife Service. Those familiar with the USGS's work will tell you bird banding isn't limited to waterfowl. In fact, numerous bird groups—including seabirds, shorebirds, raptors, passerines and others—are banded.

The whole process of reporting a band has been simplified through technology; anyone can report online or call a toll-free number. I've seen young hunters with iPhones report bands from their duck blinds and have a reply from the Bird Banding Lab before the morning hunt was over. What's more, certificates of appreciation are now downloadable electronically and made available to every person who reports a band.

In less than twenty-four hours, I had my certificate printed and in hand. Upon learning who banded the gull and where it was released, it became clear to me the bird survived the worst manmade environmental disaster in U.S. history.

The banded laughing gull was the 1,027[th] oiled bird brought in to Fort Jackson, Louisiana, on July 21, 2010, where a team from Tri-State Bird Rescue and Research Incorporated administered treatment. What's more, staff veterinarian Dr. Erica Miller, whose name was listed on the USCG certificate as the person who banded the gull, did the initial examination on the bird.

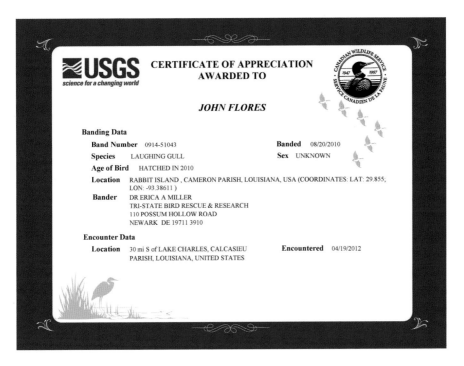

USGS band certificate.

Miller was able to refer to her veterinarian notes to obtain specific details on birds that were treated by Tri-State Bird Rescue. The laughing gull was a hatch-year non-flight bird when it was rescued, Miller related. It still had immature plumage and was lightly oiled all over but moderately oiled on the neck and vent areas. What's more, the bird had oil inside of its mouth.

Miller said that there were a number of colonies that got hit, and hundreds of juvenile gulls were brought in. Following the administering of fluids, according to Miller, the young laughing gull was stabilized and later moved to Hammond, Louisiana. At the Hammond center, the hatch-year bird was cleaned, rehabilitated and raised until old enough to survive on its own. The bird was then released on Rabbit Island in the west cove of Calcasieu Lake near Lake Charles on August 20, 2010, over three hundred miles from the spill's impact area, which was still spewing millions of gallons of oil into the gulf.

The Deepwater Horizon Bird Impact Data, published by the Department of Interior–U.S. Army Engineer Research Development Center's (DOI-ERDC) Natural Resource Damage Assessment and Restoration process

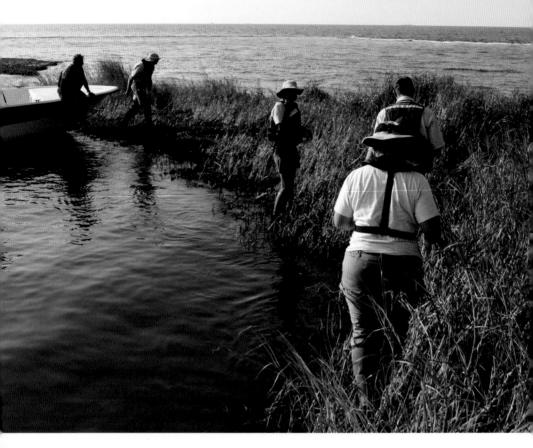

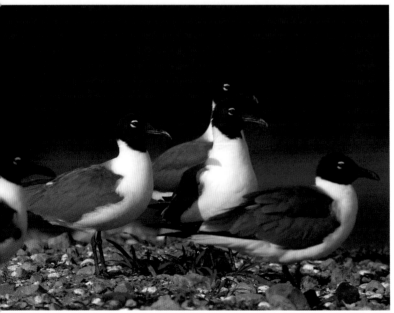

Above: Mike Carloss leads a team of rescuers looking for colonies of nesting birds along an oiled barrier island affected by the Deepwater Horizon oil spill disaster. *Courtesy of USF&WS.*

Left: Though a common bird along the bayou, the laughing gull suffered the highest number of losses during the Deepwater Horizon oil spill.

(NRDA), reported an all species grand total of 7,258 dead birds in May 2011. Of these, 2,981 were laughing gulls—the highest known death total.

What is the significance of encountering a banded laughing gull two years after the disaster?

In her own words, Miller explained:

> *To me personally this is a real significant recovery or banding encounter, because I obviously think what we do works—that's why we do it. If I thought it wasn't worth it—wasn't worth the effort treating these birds, because I thought they were all going to die as some people had said—then I wouldn't be doing it. So, putting the bands on the birds is one easy way we have to show that, or hopefully show that, they did survive.*

A National Geographic Daily News story titled "Oil-Coated Gulf Birds Better Off Dead" by Christine Dell'Amore cited German biologist Silvia Gaus in arguing that workers helping birds caught in the Deepwater Horizon Spill should "kill, not clean." The article went on to say that other studies have proven otherwise.

The species with the second-highest number of known dead was the brown pelican, totaling 826. Due to its large size, encounters and sightings were common in the aftermath of the catastrophe. Two years after the spill, 130 brown pelicans that were banded during the disaster had been sighted and reported alive, but no laughing gulls.

Although there were lots of gulls banded, it's less usual to get reported encounters from them, officials say. Essentially, the smaller the bird, the less frequent the returns. Miller emphasized that unless you have the smaller bird in hand, which in many cases means the bird is dead, reporting is far less encountered as a result.

USF&WS biologist Jereme Phillips, along with many others from the service, was involved in the spill from the very beginning. Phillips says the report from a confirmed encounter with a banded laughing gull is extremely significant.

Phillips, who worked for the USF&WS as refuge manager in the southeast region during the oil spill, is worth quoting.

In expounding on the collaborative accomplishment of agencies involved in wildlife rescue efforts, Phillips said:

> *I think in some ways it represents the countless hours that people dedicated to cleaning and caring for oiled birds. These efforts often involved long hours at rehabilitation centers being covered in oil and feathers. And, as most of*

us remember here on the coast, this work took place in the absolute hottest part of the summer.

Phillips continued:

I think in many ways it represents all of the hard work of many, many people, including the biologists with the Fish and Wildlife Service, but also our partners with our state agencies and nonprofit organizations who got involved in the oil spill. There were about 1,423 birds I think at last count that were rehabilitated and released. And, more than one hundred species. Actually, laughing gull was the most common bird that was brought in to rehabilitation centers. So, there is another reason why this encounter is a good symbol of what happened.

Like sparrows, doves and robins, laughing gulls are fairly common. The USF&WS manages more than 150 million acres of wildlife habitat on 556 National Wildlife Refuges. The department doesn't micromanage the regions it's responsible for.

Phillips pointed out that the USF&WS can't take any species for granted. It's important to save as much wildlife as possible after such a disaster. What's more, he said, it's the goal of the service to manage all species and whole ecosystems, not just rare or endangered wildlife. By managing all species, hopefully none will get to the point where it becomes rare or endangered.

Phillips concluded that the rescued laughing gull and its subsequent encounter two years later was a good example of the USF&WS fulling its mission and dedication to achieving those goals.

According to studies, since 1930, more than 2,100 square miles of Louisiana coastline has been lost from erosion due to sediment loss and other contributing factors. It is estimated that every thirty minutes, an area the size of a football field disappears. The challenges Louisiana's human population and wildlife face in the future are substantial.

No one can predict what the chances are of another environmental disaster on the scale and magnitude of Deepwater Horizon occurring. Our local economies and the nation depend on the gulf's rich supply of energy. We can only hope it never happens again.

In a lot of ways, the story of one banded laughing gull caught by an outdoor writer two years after a rough start in life shows Louisiana's resiliency. So, as fate would have it, what are the chances of other rehabilitated birds surviving like 0914-51043?

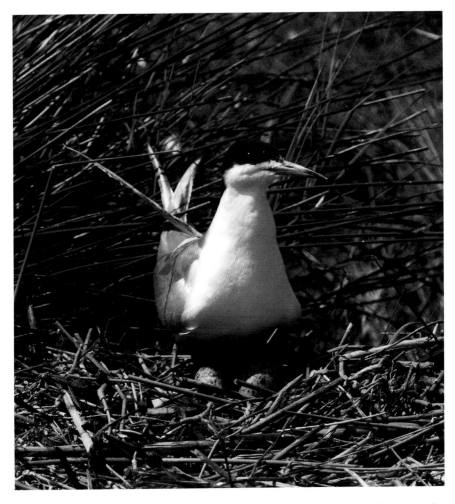

Bird rescuers from several agencies worked hard to save as many birds as possible during the BP oil spill.

Miller remains resolute in what rescuers were able to accomplish against long odds:

> *Having a report—two years out—of a bird that obviously has survived in the wild for two years after having been oiled and gone through the rehabilitation process and everything—is a very significant find for me. It's, "See! I thought so!" So, now we can say we have a piece of data that says, "Yes, they do survive."*

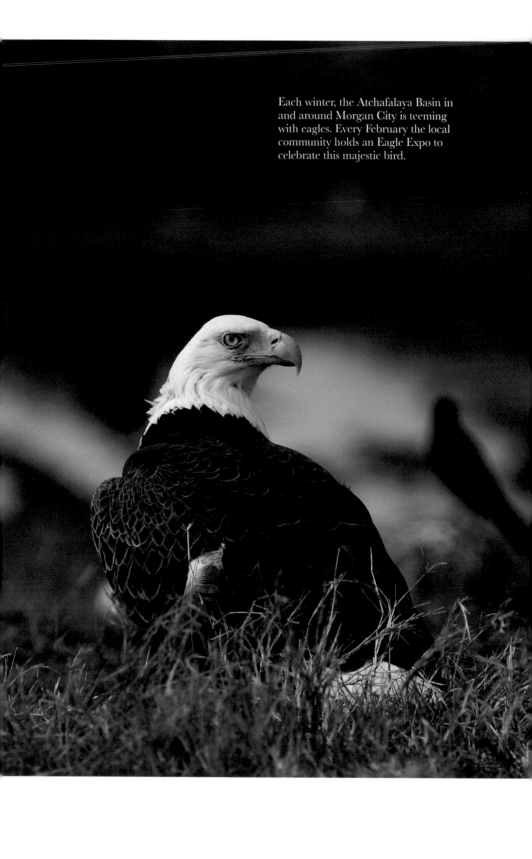

Each winter, the Atchafalaya Basin in and around Morgan City is teeming with eagles. Every February the local community holds an Eagle Expo to celebrate this majestic bird.

BALD EAGLE COMEBACK

A Case of Coming to Terms to Coexist

Author's note: Once on the verge of extinction, the American bald eagle was delisted from the threatened and endangered species list by the USF&WS on June 28, 2007. Today, the symbol of our nation again graces the skies all across America in relative abundance, but perhaps none more than the city of Morgan City, Louisiana.

With massive wings pushing against the air to slow its descent, the bald eagle dropped toward the concrete surface of Oceaneering International Incorporated's manufacturing yard in Morgan City, Louisiana.

Oceaneering's complex rests along the Avoca Island Cutoff, where it not only builds but also mobilizes equipment to support the offshore energy industry in the Gulf of Mexico.

Surprised, Ira Finley, who works for Oceaneering as a yard technician, called out to a nearby co-worker, "Hey! Look at that eagle," before the huge raptor lifted off the ground.

Holding his arms out wide and clearly amazed, Finley excitedly described the eagle's enormous size: "Its wings spread out at least three or four feet. It was huge. It went to land and grab a piece of trash that was moving along the ground in the breeze. When it realized what it was, it flew up and lit in the top of an oak tree."

Finley theorized that the company, having a very large side yard full of old dive equipment, would have rodents and other small mammals

the eagles would eat. Since the overgrown storage area had little human traffic, to the yard technician, it stood to reason the eagles would perch over it looking for a meal.

Stories like Finley's have occurred up and down the waterfront property of numerous oilfield businesses that are part of the old Intracoastal Waterway south of Railroad Avenue. Here the energy industry meets the prime wetland habitat eagles prefer around the Atchafalaya Basin. Moreover, it's where they have adapted and learned to coexist with humans. It's not uncommon to see bald eagles perching on top of massive 275-ton crawler crane booms, some 150 feet up in the air, surveying the surrounding waterways.

Decimated by loss of habitat, illegal shooting, pollution and pesticides such as DDT, the bald eagle was pushed to the brink of extinction, and in 1978, the raptor was placed on the Endangered Species List.

The late Tom Hess, a Louisiana Department of Wildlife and Fisheries biologist supervisor at Rockefeller Wildlife Refuge in southwest Louisiana, participated in some of the early efforts to protect and restore the bald eagle. During an interview following the eagle's delisting, Hess said rules had to be developed to protect them but could not be so restrictive they became a detriment to industrial commerce.

According to Hess, in the early '70s there were approximately five active nests documented by department personnel. One of them was in Gibson, a small town fifteen miles east of Morgan City. At the time, this was considered the center of the bald eagle's presence in the area, and Hess likened it to being "the last stand of the eagles."

The LDWF's approach to protecting eagles was simplistic. Protect the nest trees, don't touch or damage a nest tree and keep a buffer around the nest tree.

Initially, the enforced buffer zone was one mile. However, after completing some research, officials reduced the buffer to 1,500 feet. Later, when it was discovered an airboat could run about 750 feet away from a nest tree without affecting nesting, the buffer was reduced to 300 feet—the length of a football field.

During the early days of those restrictions, St. Mary Land & Exploration Company land manager James Duay expressed the difficulty energy construction crews had servicing production platforms and pipelines in the marsh the company owned and operated that were close to a pair of eagle nests that happened to show up one winter in the late 1980s. Duay, now deceased, spoke of how operations would invariably be shut down, impact

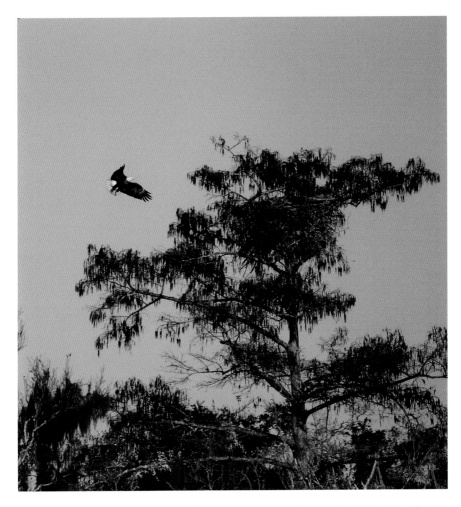

Massive nests such as this one in top of a cypress tree along the coastline in St. Mary Parish are becoming more and more common with the resurgence of the bald eagle.

studies were conducted and permits eventually issued. These things always took time. And time was something energy companies had little of.

The old saying known by most rig hands, roughnecks and roustabouts is "The oil field never sleeps." The bald eagle nests interrupted business as usual for the energy companies in proximity.

Biologists were cautious at first and tried to apply science to the decisions they made. When it came to energy projects in the surrounding wetlands, the LDWF would eventually develop workarounds for people to get their work done and protect the eagles at the same time.

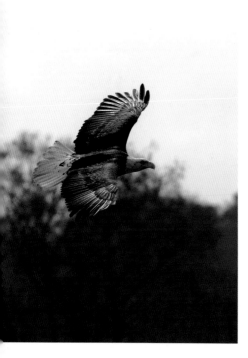

The epicenter of its recovery, bald eagles today soar over the bayou communities of Berwick, Morgan City and Houma, Louisiana.

At the time, Hess felt that the key to all endangered species was being able to integrate people's work and keep the industry going, because that is what promoted conservation.

In 1992, the department increased its surveillance efforts, initially documenting some forty-five active nests. The number eventually doubled to ninety and increased in subsequent years; prior to delisting, they numbered in the hundreds. What's more, industry had little to no impact on the population.

By the time the department quit surveying in 2007–8, it had reported 387 active nests that produced 530 young. This was significant, as biologists determined that in order to maintain their population, bald eagles had to statistically produce .9 young (basically, one bird) per nest. Department research showed the average young per nest was 1.37, far exceeding expectations. What's more, it was a number that stayed at the high production level.

When it came to discussing eagles, Hess always had a matter-of-fact way of putting things. The USF&WS and the LDWF put in countless hours researching, managing and even enforcing the rules and regulations developed to protect eagles.

Hess said just prior to the bald eagle's delisting,

The eagles have come back in a big way and the reason for that is people quit shooting them and also there's an improvement in water quality. But, nobody in industry intentionally pollutes anymore really. It's so much better today. Those eagles hanging around industry, sitting on top of cranes and equipment—it's really pretty cool. They get acclimated and habituated to boat traffic and the work out there in the wetlands. They know workers aren't going to hurt them. They are smart in that respect.

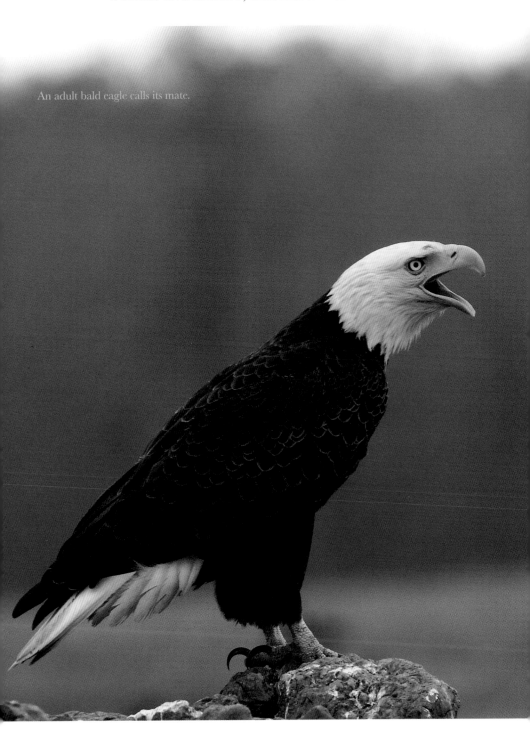

An adult bald eagle calls its mate.

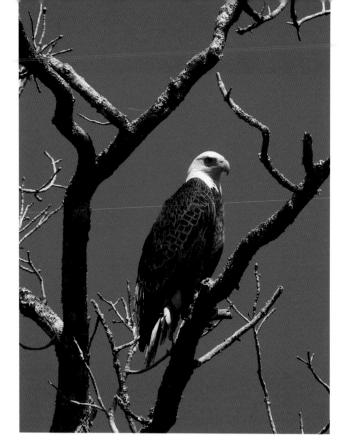

Left: Bald eagle perched in the Atchafalaya Basin.

Below: The Eagle Expo in Morgan City draws visitors from all across the United States.

Where wildlife is concerned it's all about energy to survive. Whether energy is to put on fat reserves to produce young, migrate long distances or survive harsh winters or periods of drought, birds and mammals are similar. It's often the easy meal, where little to no physical energy is expended, that makes the difference.

Bald eagles also happen to be carrion eaters and will scavenge just like vultures. As the local population of eagles has increased to where it has become commonplace to see one, eagles have found a ready-made food source as a result of human development at the local landfill in Berwick across the Atchafalaya River from Morgan City.

My spouse and I have taken trips to the dump just to observe and photograph up close bald eagles. Initially, my wife said she was disappointed to know that the majestic bald eagle was such a scavenger. Nonetheless, on any given day during the winter and early spring, eagles are there stealing food from vultures, common grackles and seagulls at the town dump.

Florida, South Carolina and Louisiana are all big eagle states. In Florida, they are categorized as urban, suburban and country eagles. The urban eagles are in places where there are lots of people. It's not uncommon to find eagle nests in people's yards. Instead of hanging around cranes and barges like they do in Morgan City, Louisiana, eagles often reside in Florida neighborhoods.

Other eagles are shy and timid—they're wild and stay back in the country. However, the one reason they are hanging around the dump is they're making an easy living eating scraps.

Though the bald eagle was removed from the endangered species list in 2007, studies continue in order to learn more about them, particularly winter breeding and summer non-breeding home ranges. In 2011, an effort to capture a number of bald eagles to place GPS satellite transmitters on them was conducted in the Houma area, thirty-seven miles east of Morgan City, on Mandalay National Wildlife Refuge. Ten bald eagles—five adults, three sub-adults and two sub-adults that became adults—were captured.

Over the course of 2012–14, all spent the winter breeding season in Louisiana, and they eventually migrated north and spent at least one summer non-breeding in Canada.

Essentially, 70 percent of all the eagle nests currently documented in the state of Louisiana are within a fifty-mile circle, with Gibson, Houma and Morgan City at the center. However, their territory is expanding each year.

On March 1, 2018, Fox8live published an article online, "Where Eagles Dare Has Metairie Abuzz," reporting that a bald eagle pair had built a nest

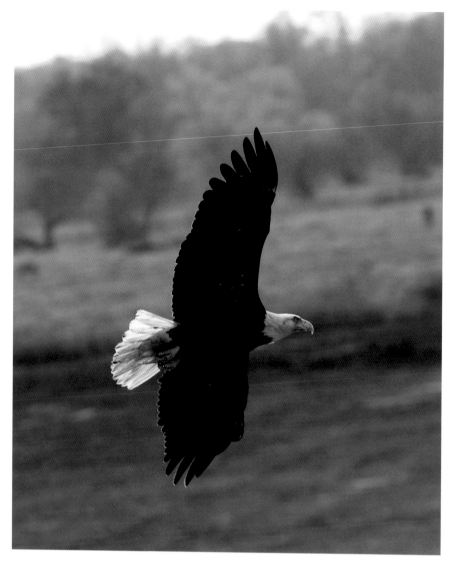

Bald eagle.

in the heart of suburbia. Metairie, which buttresses New Orleans, has a reported population of 138,481, as of the 2010 census. Metairie is located near Lake Ponchartrain, so there are plenty of food resources available for these birds to survive in this metropolis.

Through the trapping and capture program conducted on Mandalay NWR, biologists were able to track the location of the eagles every hour. By

using GPS transmitters, they were able to get an idea of bald eagles' home range, their migration corridor and how long the birds stay at each stop along the way.

According to retired Mandalay NWR manager Paul Yakupzack and Paul Link, a biologist for the Louisiana Department of Wildlife and Fisheries, one of the eagles captured and equipped with satellite telemetry during the study was tracked to southwest Michigan in its migration and another tracked well into northern Canada.

The Morgan City area celebrates the bald eagle in late February with its Annual Eagle Expo. Guests have the opportunity to participate in lectures, photography workshops, raptor demonstrations and eagle tours into the Atchafalaya Basin and coastal marshes surrounding the city.

Morgan City is just the place to celebrate this glorious raptor. After all, perhaps no place else in the United States was the bald eagle's recovery a coming to terms to coexist.

The community of Grand Isle opens yards for birders during the spring festival.

6

SPRINGTIME IS FESTIVAL TIME

Author's note: Perhaps nowhere are birds more celebrated than in the coastal communities of Louisiana. The Eagle Expo in Morgan City, the Bear & Birding Festival in Franklin, the Great Louisiana BirdFest in Mandeville and the Grand Isle Migratory Bird Festival are held each spring, and all are worthwhile events to attend.

Walking the side streets of Grand Isle, where prominently posted signs read "birders welcome" and "open yard," Emma Hart and her father, Mike Hart, spied a rose-breasted grosbeak voraciously eating red mulberries until the juices stained its beak. Even though the bird would wipe its beak on the limbs it was perched on, there was no escaping the lipstick appearance it had.

From Chappaqua, New York, Hart and his daughter traveled all the way to Grand Isle, along the Louisiana coast, to attend the Grand Isle Migratory Bird Festival held annually on the island—always around the third weekend in April.

"You're looking at a future ornithologist," Mike Hart said to no one in particular while affirming his daughter. The smile on Emma's face said it all.

It was Emma's birthday present from her father. When he asked her what she wanted for her birthday, she simply said she wanted to go and see some birds.

Grand Isle, located at the end of Highway 1, is an important first resting point for trans-gulf migrants. The tiny fishing and oil field service

Above: No town celebrates birds more than Grand Isle, Louisiana. Annually, this small fishing community hosts the Grand Isle Bird Festival with open yards, welcoming visitors from around the world.

Left: Mike Hart, from Chappaqua, New York, brought his daughter Emma to Grand Isle as a requested birthday gift.

Opposite: Emma Hart, a future ornithologist, enjoying birds on Grand Isle in an open yard.

community is flush with camps that many recreational anglers often consider their second homes. In the center of the island is a ridge of oak trees, hackberry, scrub maple and myrtle trees that offers immediate refuge and refreshment to birds that just made their trans-gulf migratory journey stateside.

What makes this festival so special is that it's common for many of the island's residents to graciously open their yards to birders. What's more, many of the townspeople have planted mulberry trees to attract the feathered migrants, making the yards a hospitable location for them to stop over.

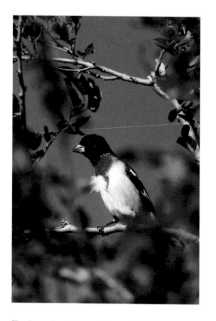

Each spring, from Johnson's Bayou in Cameron Parish to Grand Isle in Jefferson Parish, the rose-breasted grosbeak graces the Louisiana coastline for only a moment, as the transient visitor makes its way north following a brief stopover.

In one tree during the birding festival, which takes place at peak migration, it's not uncommon to see several different species at the same time. Rose-breasted grosbeaks, Baltimore orioles, summer and scarlet tanagers—just to name a few—have been seen hanging out in the same mulberry tree.

In a wooded area on the island is a small piece of Nature Conservancy of Louisiana property. It's common to see magnolia, hooded and prothonotary warblers and numerous other neotropical migrants that often fall out on the isle.

Several hours' drive northwest of Grand Isle, Sherburne Wildlife Management Area, the Atchafalaya National Wildlife Refuge and Corps of Engineer properties were the location for the Neotropical Birding Tour. The event was formerly held in conjunction with a "Step Outside Day" program designed by the Louisiana Department of Wildlife and Fisheries to teach and inform children of the many outdoor activities available to them.

Normally taking place on the Saturday prior to Mother's Day in May at Sherburne Wildlife Management Area Complex—off of I-10 exit at Whiskey Bay between Lafayette and Baton Rouge—the tour was popular among the birding community. And though the tour has taken a hiatus

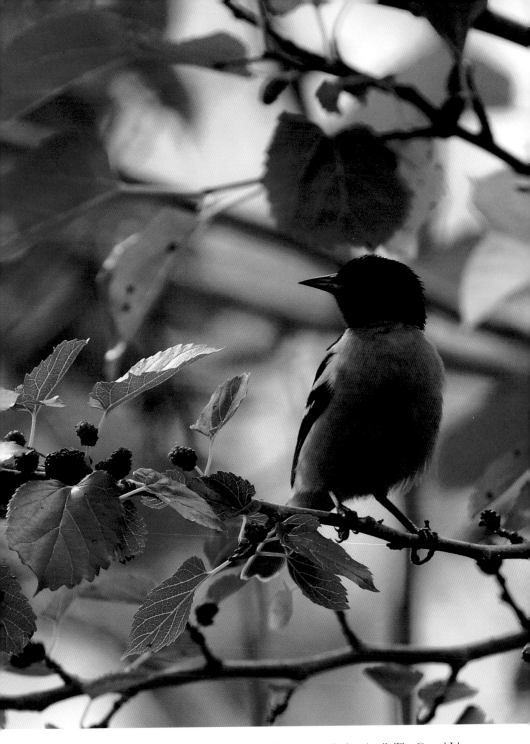

Baltimore orioles are common migrants, typically arriving during April. The Grand Isle Bird Festival, held the third weekend in April, is a great time to see this beautiful bird in the many open yards throughout the community.

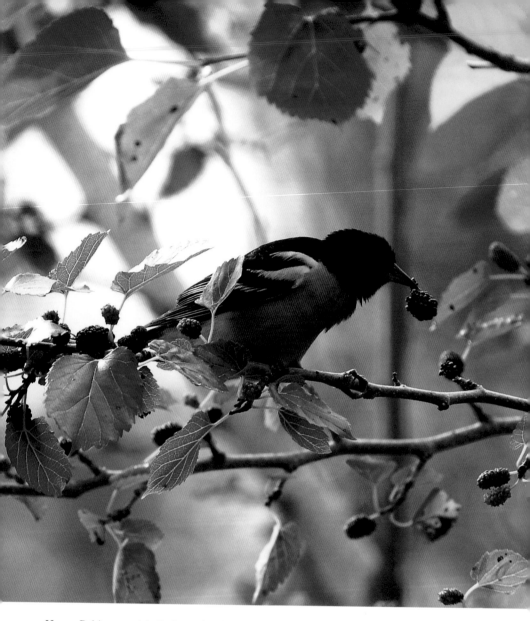

Here a Baltimore oriole feeds on ripe, juicy red mulberries in an open yard on Grand Isle.

from the spring calendar of late, the birds still are there in full splendor at this time of year.

Jay Huner retired as director of the UL–Lafayette Crawfish Research Center in 2005. Because crawfish, rice and catfish pond wetlands are critical water bird habitats, Dr. Huner devoted over thirty-five years studying birds in those systems. Huner, whose last major research project before retiring

was to survey birding resources in the Atchafalaya Basin, was instrumental in the organization of the Neotropical Songbird Tour at Sherburne.

The Neotropical Songbird Tour, according to Huner, was organized to get the attention of non-hunters and non-fishermen to the Sherburne WMA complex. Huner pointed out that many people drive past the exit on I-10 and never drive down the side roads toward U.S. 190.

Essentially, L.A. 975 runs north and south perpendicular to Interstate 10. L.A. 975 runs parallel with the Corps of Engineers' levee and Sherburne WMA. What's unique about this stretch of road is, it has been watched for over twenty-five years during the North American Breeding Bird Surveys. Sherburne typically falls in the top ten survey sites counted and birded every year. And its sister refuge, the Atchafalaya National Wildlife Refuge, is considered a globally important bird area by the American Bird Conservancy.

Sherburne WMA also is home to a summer population of wood storks. The stork's numbers are stable throughout its range according to the North American Breeding Bird Survey, but the birds only inhabit a few small regions of the United States. Sherburne is the only WMA in the state that holds a Wood Stork Day, providing the general public an opportunity to see these unique birds each July.

Birding is an excellent way for families to enjoy outings together. Small communities throughout Louisiana have recognized this fact and have created festivals to draw eco-tourists to their towns.

There are numerous books available at local libraries and retail outlets to help identify some of the more common species of birds wherever you're going. There are also online sites with free checklists available to the public.

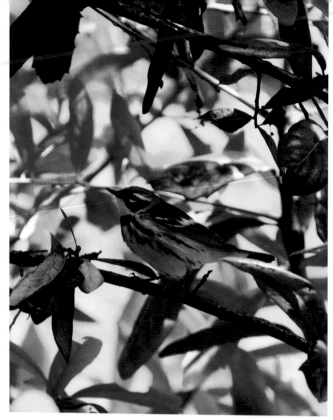

Left: A good time and place to see magnolia warblers, if you're in Louisiana, is during the latter part of April at the Grand Isle Bird Festival. Other locations are along the Creole Trail on Sabine National Wildlife Refuge, Johnson Bayou, Peveto Woods Bird Sanctuary and Pecan Island.

Below: The yellow-breasted chat is another common bird along the bayou. The largest of warblers, its song is somewhat harsh compared to smaller warblers.

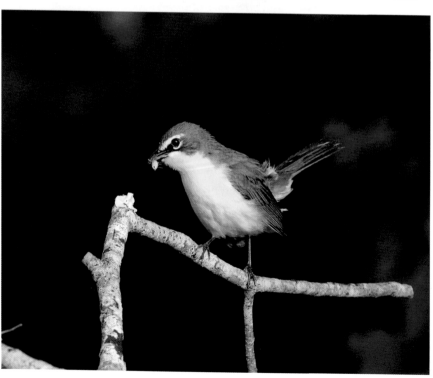

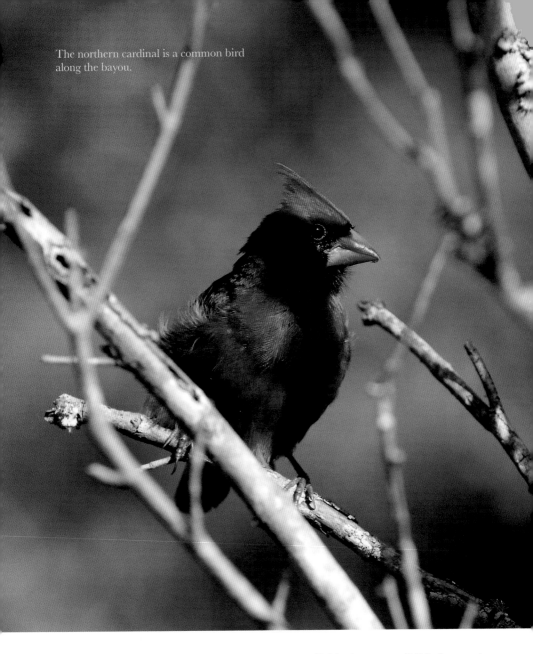

The northern cardinal is a common bird along the bayou.

One excellent site where checklists are available is www.wildbirds.com/find-birds/State-Province-Checklists. Simply scroll down to "checklists" and click your state or province. If Louisiana is your destination, then click on Louisiana and click on Louisiana Ornithological Society.

Every national wildlife refuge has checklists of what birders can expect during a visit. Doing a web search of the particular NWR you're interested in visiting can be a game changer when it comes to planning ahead.

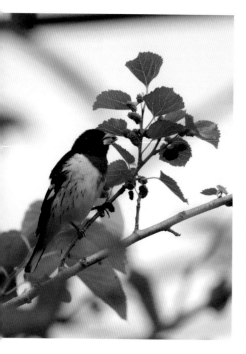

Rose-breasted grosbeak.

For the techie who prefers using a smartphone for birdwatching rather than a hard-paper checklist and pen, there are birding apps available that you can download. One such app is the Sibley eGuide to the Birds of North America. Another is called BirdsEye App, which is powered by eBird—a joint project of the Cornell Lab of Ornithology and Audubon.

An excellent website and travel guide for birding Louisiana can be found online by going to www.louisianatravel.com/louisiana-birding-trails. This site will provide locations, descriptions, directions and cultural attractions through 22 parishes and 115 birdwatching sites, primarily in the coastal regions, known as loops. In addition to these loops, the website also provides other birding trails throughout the state. It's a can't-miss website for planning purposes and is part of the "Feed Your Soul" theme the state has adopted for visitors.

Each spring, thousands of egrets migrate to the Avery Island rookery that E.A. McIlhenny founded in the late 1890s to protect them from the plume hunters who sold their feathers to make ladies' hats. Bird City in Jungle Gardens is open to the public; late winter and the first days of spring are the best times to visit.

Between the end of January and the first few weeks of February, great egrets come first, the herons next and then snowy egrets, followed lastly by cattle egrets. There is an observation deck that people can climb, and it provides excellent viewing and photography opportunities.

March is an ideal time to plan a trip to Avery Island and Jungle Gardens. By the second weekend in March, the azaleas are in bloom on the island. Besides the aforementioned egrets, other common birds found on Avery Island during the spring include the white ibis, little blue heron, green heron, roseate spoonbill, neotropic cormorant, anhinga, belted kingfisher, eastern kingbird and many others.

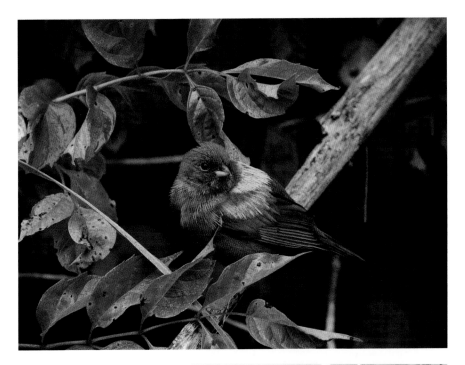

Above: Painted bunting.

Right: Summer tanager.

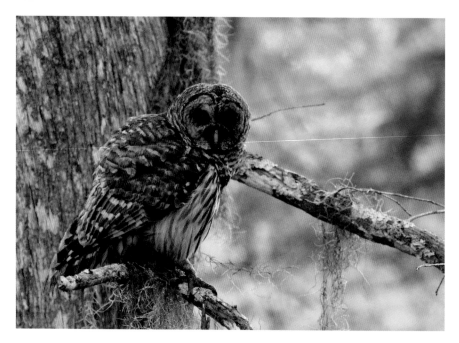

Above: Barred owl.

Opposite: The white-faced ibis is a common wading bird in Louisiana's coastal marshes.

It is suggested that people come periodically to observe the birds at different stages throughout the spring. A birder can see egrets perform mating dances at certain times and young broods as eggs hatch.

Jungle Gardens offer regular bird tours seven days a week from 7:00 a.m. to 5:00 p.m.

Resting in the center of a triangle between Lafayette, Breaux Bridge and St. Martinville is Lake Martin. Next to Lake Martin is the Cypress Island Nature Preserve, owned and operated by the Nature Conservancy. The preserve is approximately 9,500 acres consisting of a cypress-tupelo swamp and bottomland hardwood forest, much like the nearby Atchafalaya Basin. The area is a hot spot for viewing wading birds, neotropic songbirds and other passerines.

This preserve is all about birds. Visitors have a two-and-a-half-mile walking trail that is open from the fall through spring to allow alligators to nest in the summer months. Cypress Island also has a visitors' center to educate and provide information to people. Visited by thousands of people from around the world annually, it also is an ideal habitat for scientific research.

Left: The osprey is a coastal raptor that's vulnerable to habitat loss and coastal pollution.

Below: Eastern kingbirds are the black-and-white enforcers of the bayous, chasing crows and raptors away with a vengeance. *Photo by Christine Flores.*

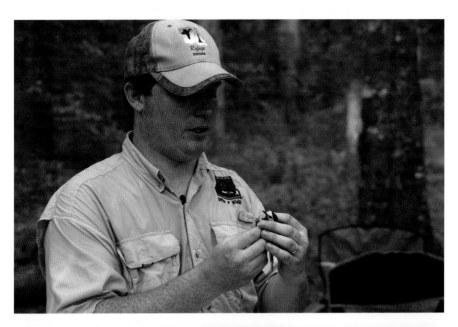

Top: Louisiana Department of Wildlife and Fisheries biologist Michael Seymour does mist net demonstrations for birders attending the Grand Isle Bird Festival.

Bottom: Seymour bands a hooded warbler.

Hooded warbler.

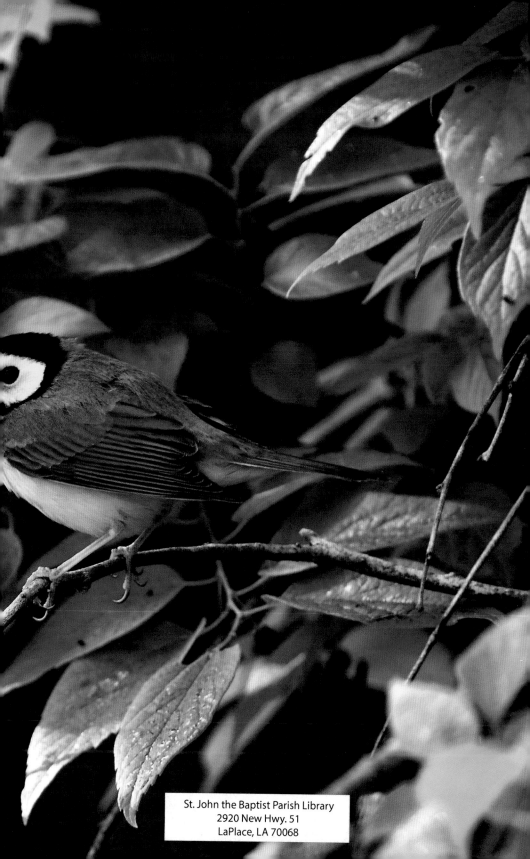

Within the city limits of Lafayette is the Acadiana Park Nature Station and Hiking Trail. A portion of the walking trail is an elevated boardwalk surrounded by forested swamp. Though it lacks the pristine natural environment of a refuge or wildlife management area, it is an ideal location for songbirds.

Neotropical songbird migrants move into and through the region from mid-March to mid-May, whereas wintering birds tend to leave between early April and early May. Aggressive birders can generate daily lists of over 125 birds in the coastal bayou areas, including migrant, wintering and resident birds.

Some migrants, like purple martins, have invaded the Gulf Coast region by the second weekend in March. They immediately and readily seek homes high above the ground in the form of birdhouses constructed by humans. If properly built and placed at the right height, martins are safe from four-legged predators, such as feral cats.

All across coastal Louisiana during the spring, communities such as Franklin, Grand Isle, Mandeville, Morgan City and Jennings cater to birders not only for the commerce these groups of people generate but also simply to celebrate and share part of their local heritage. However, over the years, birding festivals haven't been limited to just spring. In the past, Louisianans have celebrated fall festivals, including the Folsum Butterfly & Hummingbird Festival, the Yellow Rail & Rice Festival in Crowly and the Lafayette Hummingbird Day.

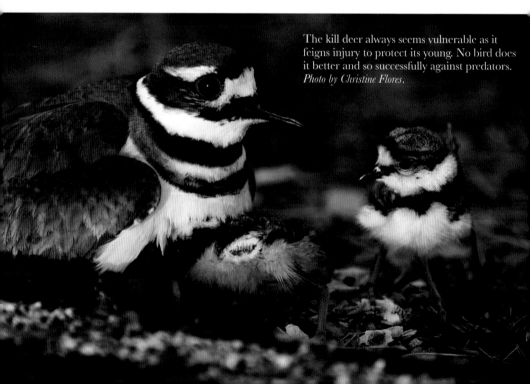

The kill deer always seems vulnerable as it feigns injury to protect its young. No bird does it better and so successfully against predators. *Photo by Christine Flores.*

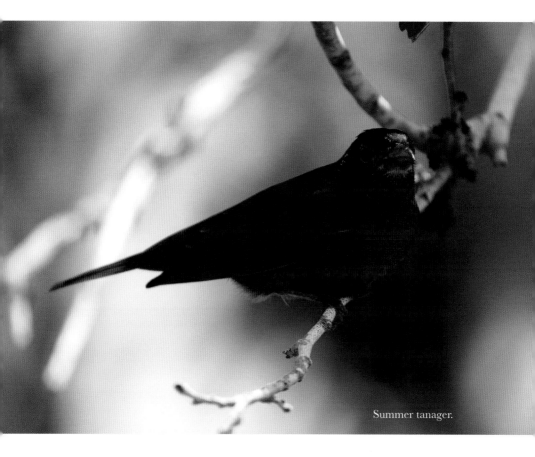

Summer tanager.

Louisiana's people have lived off the land and, as such, developed a heritage that oftentimes included names for birds unfamiliar to ornithologists in other parts of the country. My father-in-law would hear the cry in the evening of a king rail and say to his grandchildren, "Did you hear that? That's a cop-cop bird."

Many of the old-timers of French decent made their living trapping furbearing animals in the marsh during the winter months. They had names for different species of waterfowl. American coots were called *poule d'eau*. Scaup and ringneck ducks were referred to as *dos gris*. And redheaded ducks were called *tete rouge*.

With such a rich culture and heritage, many of the communities across Louisiana love to celebrate and share their traditions with visitors. So why not take in some of that culture by attending a local birding festival? One thing folks will learn immediately—Cajuns know how to celebrate and pass a good time.

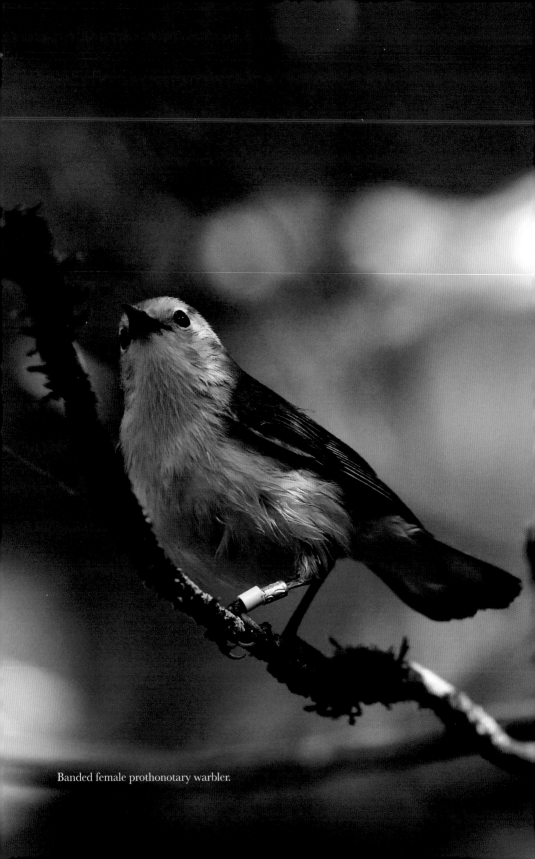

Banded female prothonotary warbler.

CLOSE ENCOUNTER OF THE BIRD KIND

*D*uring a 2017 spring birding trip the third weekend in April, my wife and I ventured out with our camera gear, planning to hit several of our favorite songbird locations. Nature photography happens to be our thing, just as golf, bowling or perhaps kayaking is someone else's. This particular weekend was also the peak period of the annual neotropical songbird migration, where our chances of seeing a wide variety were excellent.

Leaving our hotel before daylight, we woke up with the birds and targeted Lake Martin, particularly Rookery Road, as our destination to launch into our nature-photography adventure. Our mental anticipation meters were tipped pretty high to the positive side, with the possibility of catching some great images.

Lying between Lafayette and Breaux Bridge, Lake Martin happens to be a critical habitat for songbirds. As such, the region is a perfect place to view some of the trans-gulf migrants we like to chase each spring. What's more, it's home to the Cypress Island Preserve—a great place to start.

It was on the preserve's boardwalk where I experienced my encounter. Prothonotary warblers were singing like a glee club high up in the tall cypress and tupelo trees of the nature preserve. Then, every few seconds, we'd see them darting about, chasing one another. Their movement was so fast they were more like streaks of yellow than songbirds. But even songbirds have to stop and rest a moment.

In the low branches, just above my head, a prothonotary warbler decided to quit the chase and search the tree's bark for a breakfast of insects. Every few seconds, it would sit, then go back to its twig-by-twig search for food. I depressed the shutter button of my camera and reeled off a few bursts. That's when I saw a band on the bird's left leg.

No longer interested in a quality image, I aimed at the bird's butt, trying to catch as many shots of its legs as I could from as many different angles as I could.

We're not talking about a duck or goose band. This band is tiny. I had my telephoto lens zoomed out to its maximum four hundred millimeters. I suspected that in spite of this maximum view, I'd still have to crop the image when I got home to examine the band more closely.

My hope was to decipher enough numbers to be able to report them to the Bird Banding Laboratory at the Patuxent Wildlife Research Center in Maryland.

For the next several days, I spent hours poring over the images. And it wasn't until I was confident that I went online to report the numbers.

Unfortunately, an automated report came back via email stating my numbers were incorrect and the one I reported was from a tree swallow banded in 1973. I didn't give up though. I contacted the bird banding laboratory's person in charge of handling questions regarding federal band encounters and recoveries.

Jo Ann Lutmerding, a biologist with the laboratory, handed me off to Jennifer Malpass, another biologist, who asked me to send her some photos. Two days later, Malpass contacted me, stating she found my bird and that I was off by one digit during my examination.

The prothonatary warbler was banded in 2015 as a hatch-year female by Dr. Erik I. Johnson, Audubon Louisiana director of bird conservation, near Breaux Bridge. With this information, it's reasonable to assume that my bird, encountered in spring 2017, had made its fourth trans-gulf trip. What's more, she had returned to nest again near the location she was initially banded.

With the warbler population estimated to be 1.6 million, what researchers have found is, since the 1960s, 40 percent of the prothonotary warbler population has declined. What's more, it is estimated that 25 percent of the population nests in Louisiana, particularly the Mississippi alluvial plain. And 10 percent of the population breeds and nests in coastal Louisiana.

Research suggests that loss of habitat could be one of the primary causes of the decline of this species. In an effort to learn more about prothonotary

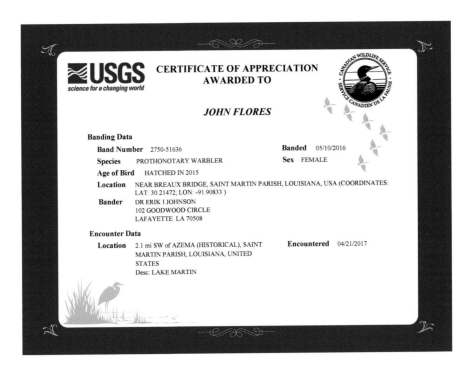

Banding certificate.

warblers, Jared D. Wolfe and Erik I. Johnson have conducted research to determine their migration routes and wintering areas using geolocator units.

In Wolfe and Johnson's *Journal of Field Ornithology* article "Geolocator Reveals Migratory and Winter Movements of a Prothonotary Warbler," the researchers reported in their abstract how one male prothonotary warbler was affixed with a geolocator unit in June 2013 on its breeding ground in Louisiana.

Geolocator units are designed to record the estimated longitude and latitude of a bird, but the information cannot be wirelessly or remotely transmitted and is stored on the device until it can be retrieved from the bird and manually downloaded. In March 2014, the male warbler was captured, and the information was retrieved.

What Wolfe and Johnson learned was the bird left Louisiana in August. It traveled 7,950 kilometers (5,000 miles) through seven countries, including the Greater Antilles, where it spent approximately one month, before moving on to Panama, or northwest Colombia near Medellín. The bird remained in Central America until the following March, when it migrated to its breeding grounds and was subsequently captured later that month.

Left: Artificial nest made from Glad container and plastic five-gallon bucket.

Below: Red-bellied woodpecker.

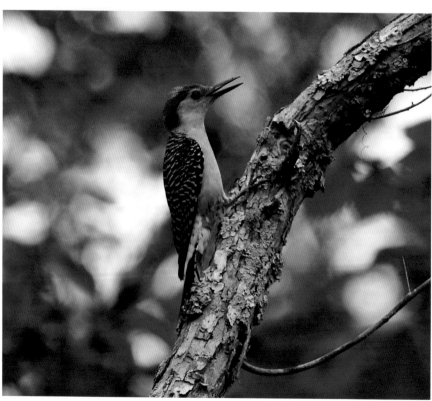

Since 2014, seventy-seven additional geolocator units have been placed on prothonotary warblers across five states.

One of Johnson's Audubon Louisiana team members, avian biologist Katie Percy, has been placing nest boxes throughout the Atchafalaya Basin and coastal region to study prothonotary warbler nesting habits. Made from a plastic Glad food storage container, a five-gallon plastic bucket, some PVC pipe, steel fence posts and a few screws, these inexpensive nest boxes have been used by many scientists for their research efforts.

Percy said the species will readily use the boxes and have plenty of room to lay three to six eggs. Incubation takes twelve to fourteen days, both parents feed the chicks and the young warblers fledge in ten to eleven days, she added.

Percy noted that the prothonotary is one of only two warblers that are cavity nesters in the United States; the other is Lucy's warbler, whose range is in the southwestern United States. Additionally, she said the prothonotary warbler's food sources primarily consist of caterpillars, aquatic insects, beetles, mayflies, leaf hoppers, dragonflies and even spiders, which is another reason Louisiana's habitat is so suitable for songbirds. It's rich in food sources.

The prothonotary's song is sweet, distinct and unmistakable. Upon arriving in their breeding range, typically in mid- to late March, male prothonotary warblers immediately go about staking out territory and will chase their competitors away. Like most birds, males will display during courtship to impress a receptive mate.

Lake Martin is an ideal location to see prothonotary warblers, as well as other songbirds. It's a place where you can see some of the artificial nest boxes that Percy and the Audubon Louisiana team have put out for studies on the Nature Conservancy property. It's this boots-on-the-ground kind of research and hard work that in the end will pay great dividends in learning more about this beautiful bird of the swamp and marsh. Hopefully, through these studies and some citizen involvement, over time, the prothonotary warbler's population decline can be reversed.

As a lover of all things outdoors in the sportsman's paradise, I miss out on a lot of good fishing during April and May weekends each year chasing birds. I've somehow convinced myself that I can always make up for lost fishing days. By contrast, you'd be hard-pressed to make up a birding day that included a close encounter of the bird kind trying to catch a fish.

Black skimmer.

PLATTE BAYOU ROOKERIES ARE THINGS THAT MATTER

*A*ll too often it's the little things that go unnoticed. And all too often it's those little things that matter so much. The Bayou Platte Waterbird Rookery Restoration Project on Marsh Island Refuge is one of those things.

Through a grant made available by the Shell Marine Habitat Program and National Fish and Wildlife Foundation, the Coastal and Non-Game Resources Division of the Louisiana Department of Wildlife and Fisheries began restoring two artificial islands located in Platte Bayou on the inside of Marsh Island back in August 2013. Originally created some twenty-six years ago for the purpose of establishing colonial sea bird rookeries, the two small islands—a result of subsidence and erosion—deteriorated to the point where nesting productivity had declined.

What makes the artificial islands so important is that they are critical habitats for colonial birds considered species of conservation need.

LDWF biologist Tyson Crouch works for the department's Coastal Operations and Marsh Management Division. The restoration of the artificial islands was a project that Crouch had been involved in from the beginning.

Crouch explained that black skimmers, gull-bill terns and least terns were all species of shorebirds in need of a higher level of conservation. Essentially, there are very few nesting areas in coastal Louisiana and no rookeries of any kind for these particular birds in the Vermillion, East Cote Blanche and West Cote Blanche Bay areas. As a result, the island

Bayou Platte water bird colony restoration.

projects were important to the region and two of the largest artificial islands developed for conservation purposes.

Marsh Island is approximately seventy-one thousand acres in size and is essential habitat for wintering populations of waterfowl, shorebirds, wading birds and raptors. It is open to the public for a variety of recreational uses such as boating, fishing, crabbing and tossing a cast net for shrimp. The island also acts as a test tube where numerous scientific and ecological research projects by the LDWF personnel and academics have taken place.

Gull-billed terns and black skimmers were highly sought after in the New England states during the late 1800s for their eggs as a delicacy and feathers for fashionable hat plumes. In an article written by Jim Daniel published on www.ncwildlife.org titled "The Plume Hunters," it was noted that during two afternoon walks in New York City in 1886, ornithologist Frank M. Chapman was able to identify bird plumage residing on 77 percent (543 of 700) of women's hats.

An American Bird Conservancy report titled "Status of Black Skimmers—Biological Review," published in 2011, discussed the bird's plight in the state of Florida. Essentially, black skimmers and other sea birds such as terns, gulls and various plovers are beach-obligate species.

The obstacles that skimmers and all colonial birds face are development, recreation, pollution, climate change, coastal engineering projects and invasive species.

The status report noted that in places like Florida, where high amounts of recreational activity occur, most colonies of birds would fail without management. Things like beach raking, ATV and automobile driving, cats and dogs all have an impact on colonial sea bird populations.

The black skimmer is an odd-looking bird in one regard, with its long reddish-orange and black bill, and protruding lower mandible. The bill is perfectly designed and suited for what the bird's name implies—skimming the surface of the water. With its lower mandible skimming the water, its bill shuts tight, capturing small fishes and crustaceans.

Its breast and underbody are white, and its back is black, much like a raven's color. The black skimmer's wings are pointed and its tail broad, ideal for controlled flight inches above the water's surface.

According to Audubon's *Guide to North American Birds*, black skimmers nest on open ground, which is typically a shallow depression they've made through scraping in the sand and gravel. They will lay between three and seven eggs. Both parents share in incubating the eggs over a twenty-one to

Black skimmer eggs hid in a shallow depression on Platte Bayou rookery.

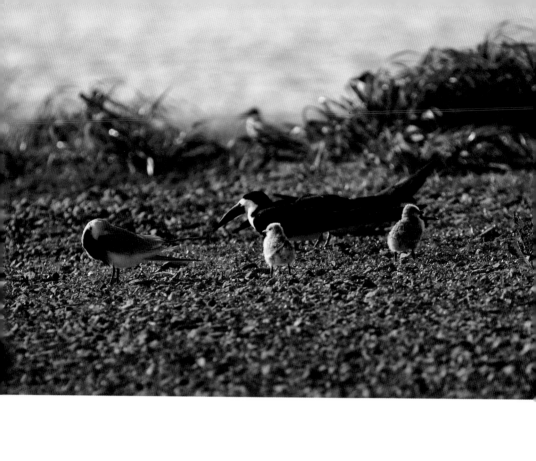
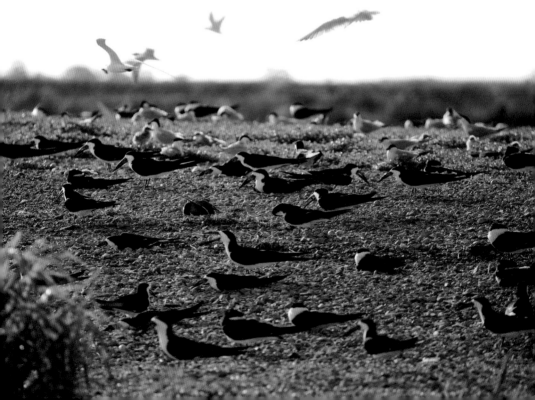

twenty-three-day period. They also share feeding responsibilities with their young by regurgitating food they've eaten. Black skimmer chicks are able to take flight in approximately twenty-three to twenty-five days.

Skimmers typically begin nesting around Memorial Day through the Fourth of July. This is also the peak recreation period along the U.S. coastline. Florida's coastal population is currently estimated at 12.3 million and predicted to double to 26 million by 2060.

An executive summary published by the LSU Economics and Policy Research Group titled "Economic Evaluation of Coastal Land Loss in Louisiana" stated between 1932 and 2010, Louisiana experienced a land loss of approximately 1,880 square miles. The report predicted the possibility of losing an additional 1,750 square miles by 2060.

After the initial construction phases, which included dredging in situ materials to raise and expand the islands in Platte Bayou, the following spring, 2014, skimmers and terns showed up, causing a work stoppage.

Crouch said workers literally had birds nesting at the foot of equipment. There was no choice but to leave them alone. In November, LDWF crews came back and worked through the fall and winter, finishing up construction in late April 2015.

According to Crouch, the islands exceeded expectations. The department's initial goal was nesting habitat for about five hundred pairs. Collectively, on both islands, researchers estimate having approximately two thousand pairs.

With the loss of nesting and foraging habitat, some species of sea birds are in decline, while others are holding their own. Conservation need doesn't mean certain species of birds are threatened or endangered but instead bear watching to ensure they continue to thrive under present conditions. Crouch said that this is something wildlife officials recognize with the two artificial islands.

As the coastline erodes, artificial islands are going to have significant usage. Marsh Island is unique in that there really is no other large island like it. It provides habitat for hundreds of species of animals.

Opposite, top: The Platte Bayou islands are essential for the long-term conservation of colonial birds in Louisiana.

Opposite, bottom: Black skimmers nesting on Platte Bayou rookery.

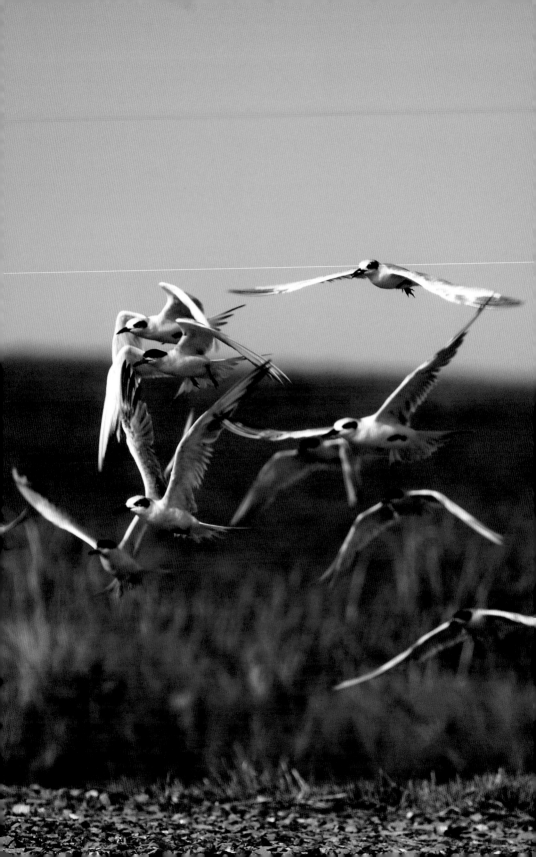

Additionally, there are very few nesting areas for colonial species of birds in coastal Louisiana and practically none in this region. The Vermillion and Cote Blanch Bay areas have no natural rookery of any kind.

In an effort to minimize a public presence, the LDWF limits access to the two artificial islands. Signage is posted on pylons in clear view that restricts boat traffic beyond a certain point. Essentially, anyone who might venture into Bayou Platte would need a pair of field glasses to see the birds reasonably well from the posted distance.

The two Platte Bayou artificial island rookeries are one and four acres in size, respectively—hardly noticeable. But then they are those little things that matter so much…

Opposite: Large numbers of Forester's terns also utilize the Platte Bayou rookery.

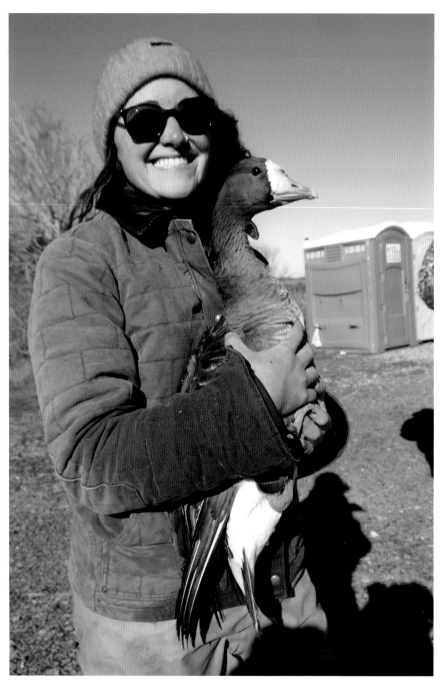

LSU PhD graduate student Elizabeth Bonczek with a white-fronted goose to be tagged with a GPS/GSM telemetry unit.

WHITE-FRONTED GOOSE TELEMETRY STUDY CONTINUES TO LOOK FOR ANSWERS

Sitting in their vehicles some two hundred yards from a grit pond in Cameron Parish, Paul Link, Louisiana Department of Wildlife and Fisheries Waterfowl Management Plan coordinator, and his team of biologists and volunteers waited. The snow, blue and white-fronted geese typically showed up at the site around 7:30 a.m. each morning.

On the grit site, Link had set up a rocket net to capture and band snow geese but hoped to catch a few white-fronted geese mixed in with them. When close to one hundred geese made their way up on the sand pile, Link fired the rocket.

Like a huge umbrella, the net spread out over the panicking flock of birds. In a matter of minutes, the team cleared the net, placing the hapless geese into crates for banding. Included in the catch were several white-fronted geese (a.k.a. speckle bellies).

Just over two decades ago, 80 percent of the midcontinent white-fronted goose population wintered in the state of Louisiana. But according to January mid-winter survey data collected by the LDWF, today, that number has dwindled to some 32 percent in spite of an increase in the overall population.

The midcontinent greater white-fronted goose population is the subspecies whose breeding grounds range from the North Slope of Alaska eastward through the boreal to Nunuvat in northeastern Canada, reaching the western edge of Hudson Bay. What's more, the geese predominately winter in Arkansas, Louisiana, Texas and Mexico.

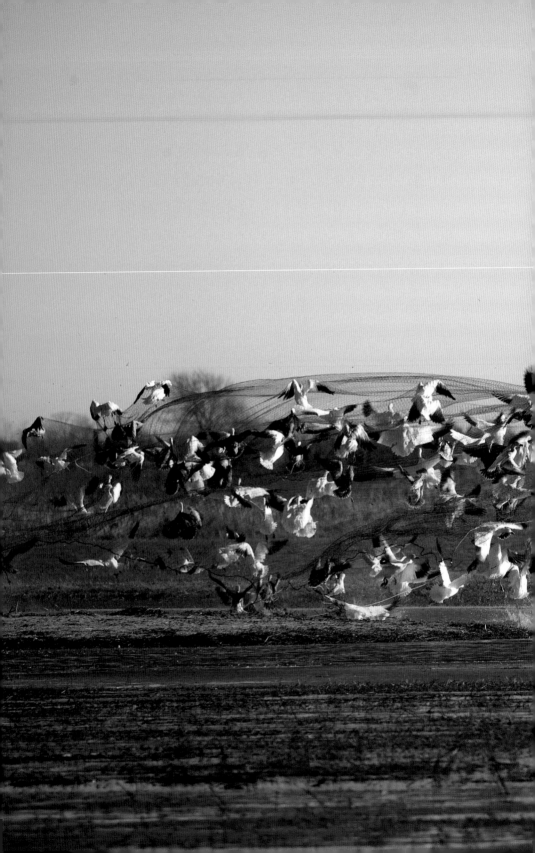

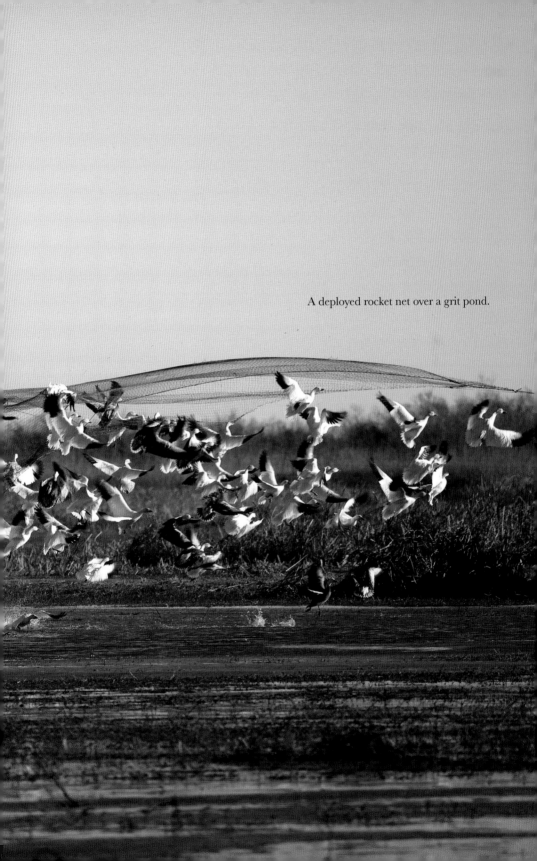

A deployed rocket net over a grit pond.

White-fronted geese are approximately twenty-seven to twenty-nine inches long with a wingspan of fifty-four to sixty-four inches. They weigh about six pounds and get their name from the circular band of white facial feathers at the base of the bill. Gray in color with darker brown tail feathers, they have brown—almost black—bar-shaped patches on the breast and belly. Hence the nickname "speckle belly."

A speckle belly's call is a series of high-pitched yodels and guttural murmurs. Their call fills the air in late October as if announcing to the local residents of Louisiana that they are back.

Reasons for the decline in winter numbers vary according to experts. Most indications suggest that post-hurricane effects, coastal erosion, agricultural changes, urbanization, industrialization and even hunting pressure have all contributed over the years. With this in mind, in 2015, the Louisiana Wildlife and Fisheries Commission assigned Link's department the task of investigating the sources of the trend to better manage the species going forward.

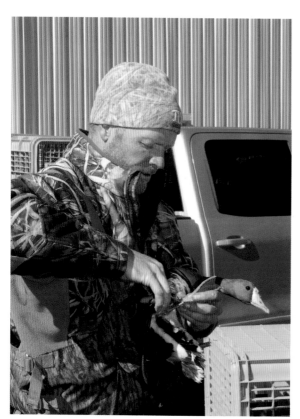

Left: LDWF biologist Paul Link banding a white-fronted goose.

Opposite: Louisiana Department of Wildlife and Fisheries Waterfowl Management Plan coordinator Paul Link fastens a telemetry unit to a white-fronted goose.

The method utilized to study the trend would be via global positioning system and global system for communications (GPS/GSM) combined telemetry collars attached to the geese following capture and banding. Each communication device is solar powered to reduce weight and estimated to last three to four years.

Paul Link, LDWF North American Waterfowl Management Plan coordinator, has lead the project since its beginning. Link said the goal of the study is gaining a better understanding of the white-front's winter ecology, including their habitat use, local and long-range movement, fidelity and philopatry and migratory pathways, which are all key to comprehending the pattern of the winter decline.

Link said a couple of surprising things he has noticed so far is the exodus of white-fronted geese on or shortly after opening day of waterfowl seasons. The biologist pointed out that they appear to be highly sensitive to hunting pressure. Secondly, there appears to possibly be a low rate of return to Louisiana, noting that only one of seven birds collared the previous year returned to the state; the others stayed north.

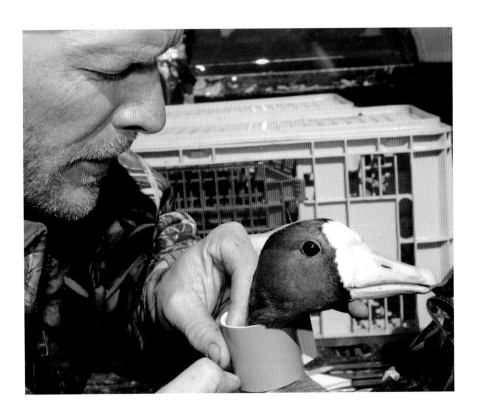

The winter migration pattern of a white-fronted goose tagged with a GPS/ GSM telemetry unit. *Courtesy of the Louisiana Department of Wildlife and Fisheries.*

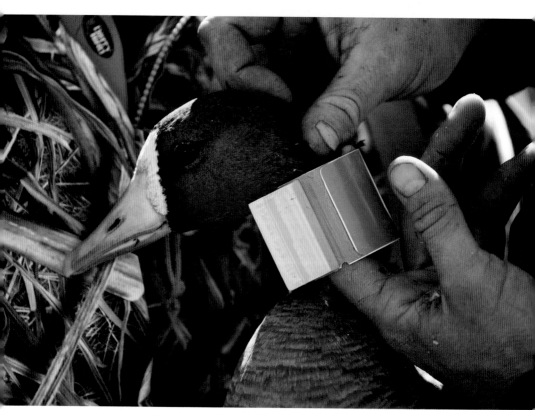

A white-fronted goose receives a telemetry unit.

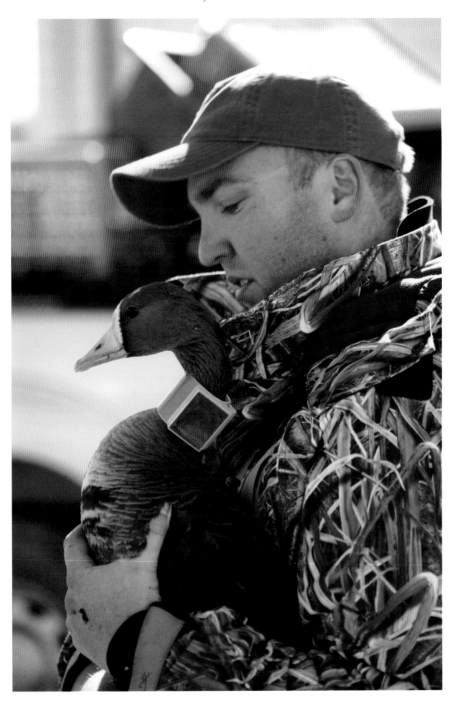

LDWF biologist James Whitaker with a GPS/GSM telemetry unit prior to being released.

Though telemetry provides dispersal details with precision accuracy, there are habitat factors that can't be assessed accurately without boots on the ground. Link tried to get technicians out to the fields that telemetry-collared birds have utilized before weather and agricultural manipulative changes take place. Pulling water control structures and plowing impede technicians from collecting information such as vegetation type as well as water height and moisture content of the locations surveyed.

Data from telemetry showed one of the birds from the study's first year nested on the North Slope of Alaska, some 3,900 miles distance from her capture location in Louisiana. However, like any technology the GPS/GSM units have their moments.

Periodically, the collared white-fronted geese go offline, typically due to poor cell service. When birds eventually relocate to better service locations, all unsent data can be retransmitted. Additionally, though rare, there have been occasions when batteries were too low to collect locations.

Waterfowl with neck collars also have had issues in the past with freezing weather conditions, where blocks of ice have formed, causing mortality. Link asserted that white-fronted geese are better candidates for telemetry collars because they don't encounter ice or snow.

At times, hunting has also presented another kind of problem. When geese are shot and not recovered, the telemetry device may be lost. One such case may have occurred when four birds went offline the same day they were captured. Link mentioned, as it turned out, some white-fronted geese that were banded with them—but did not receive collars—were reported harvested by hunters.

In follow-up interviews to learn more, hunters recalled knocking feathers off some speckle bellies; they sailed off and were unfortunately unable to be retrieved.

Link theorized that given the semi-regular observation of banded birds in proximity of radio-marked birds, he could likely assume they might have encountered gunfire. Essentially, if the geese go down in areas without cell service, go underwater or land with the solar panel down in the mud, in all probability, they won't be heard from again.

During the first year of the project, private individuals and organizations donated all of the transmitters, totaling eleven. In the second year of study, eleven of twenty-one telemetry units were donated.

It's noteworthy to point out that besides important donations from private organizations, landowners play a critical role by providing the LDWF access to capture white-fronted geese. Without private lands, Link

said his options for trapping sites are greatly reduced, because the geese move about.

The LDWF continued the study for a third year during the winter of 2017–18. The department hopes to continue annually deploying a smaller number of transmitters to maintain a long-term data set in order to look for what Link referred to as landscape level changes, as well as understand year effects (that is, warm-wet winters versus warm-dry winters versus cold-wet winters versus cold-dry winters).

White-fronted geese are not only highly prized in the southern gulf states by hunters, they're also regarded and enjoyed by nature lovers. Their call is wild and enjoyable to listen to. And their shades of gray and brown feathers and distinct white face markings make them splendid targets for photographers.

The white-fronted goose's presence in Louisiana appears to have changed over the past twenty years. One can only hope the research the Louisiana Department of Wildlife and Fisheries is now conducting will help to reverse the current downward trend the state is experiencing.

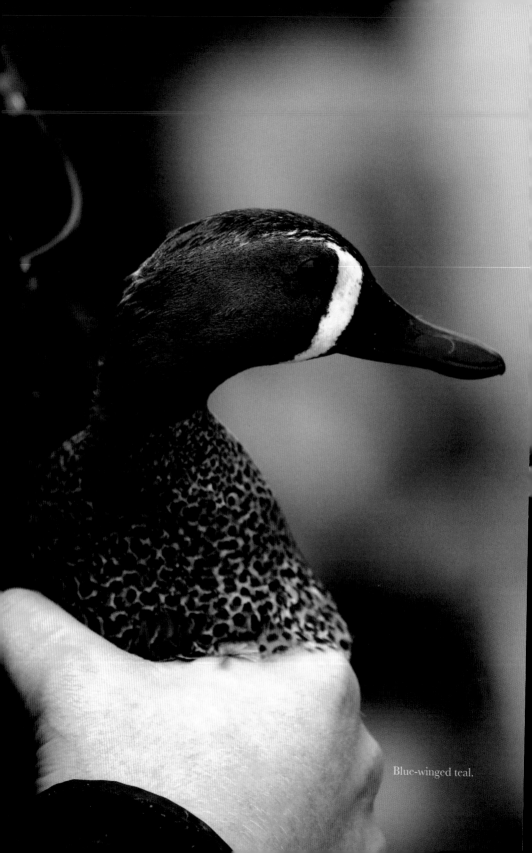

Blue-winged teal.

BIOLOGISTS SEARCH FOR VIRUSES CARRIED BY BLUE-WINGED TEAL

For the past several years, each spring, representatives from the University of Georgia–Athens, Stephen F. Austin University, the United States Geological Survey Alaskan Science Center and the Louisiana Department of Wildlife and Fisheries have been capturing and banding blue-winged teal for study to determine the intercontinental dispersal of infectious agents, mainly viruses and parasites.

Why blue-winged teal? Dr. Andrew Ramey with the USGS Alaskan Science Center said it's to mirror and expand previous virus and parasite study work done on other waterfowl in other parts of the country. In the past, the USGS has studied the dispersal of viruses and parasites of long-distance migrants such as northern pintail ducks.

As a result of the prior studies, scientists were able to determine that there is evidence pintails disperse viruses and parasites between East Asia and North America.

The current project has taken that model and moved it into a different part of North America, where researchers are specifically looking at blue-winged teal to see if they are bringing viruses and parasites with them from the northern neotropics—those countries and regions being Mexico and Central America—and South American countries like Colombia and Venezuela.

The focus is on blue-winged teal because these birds migrate farther south and they have the most widespread winter distribution in the neotropics as compared to any other waterfowl species.

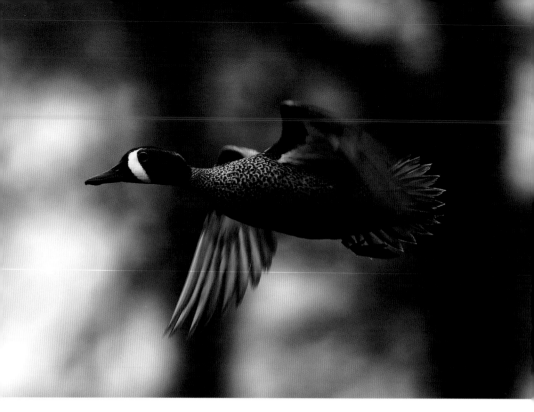

The blue-winged teal is a transcontinental migrant currently being studied.

The impact of viruses entering into the United States became critically apparent during the spring of 2015 when the price of eggs and chicken skyrocketed. Some forty-nine million poultry—mostly chickens, but also turkey—had to be euthanized as a result of avian influenza, or bird flu, at a cost of over $1 billion economically.

The early spring is the ideal period for capturing blue-winged teal in high numbers. By mid-March and early April, most duck species have left the state for their summer breeding grounds up north. However, blue-winged teal keep their own schedules. They typically are one of the first duck species to migrate south, usually in mid- to late August, but are the last to return north.

Blue-winged teal returning from their Central and South American wintering grounds linger around much of coastal Louisiana well into late spring. One Krotz Springs, Louisiana crawfish farmer claims to have seen blue-winged teal on his property in every month of the year except July. When captured at this time of year, they are typically caught in large numbers, with fewer other duck species in the mix. Occasionally, in March northern shovelers manage to show up in large numbers.

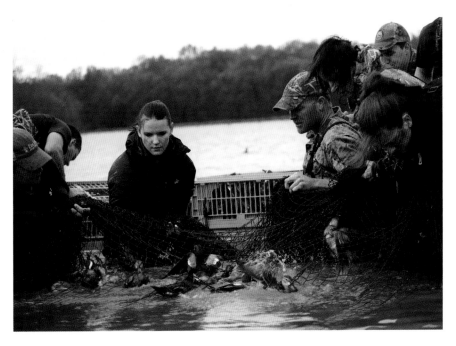

Biologists and volunteers clear a net of blue-winged teal to be banded and tested for viruses.

For the birdwatcher, this is an excellent time of year to see blue-winged teal in the marshes as a result. Male blue-winged teal are quite handsome during spring. Their iridescent bluish-gray heads with white crescent-shaped markings just in front of the eyes are a spectacle to see.

This puddle duck's beautiful markings don't end above the neck and head. The breast and sides of the male blue-winged teal are tan and dotted with dark-brown speckles, and its upper wing coverts are a soft, almost powder blue. Generally bunched up in small flocks, while driving through coastal communities, it's not uncommon to see one hundred or more during a morning outing in and around agricultural areas.

Much effort goes into planning and organizing the annual study. Paul Link, LDWF North American Waterfowl Management Plan coordinator, heads up the banding effort each spring by working with local landowners, farmers and volunteers willing to participate in the effort.

With some 125,000 birds banded during his career, most of Link's captures are made using a rocket net, which he estimates he's deployed over 1,400 times. Typically, a rocket net capture will result in upward of several hundred blue-winged teal. Therefore, it takes a large group

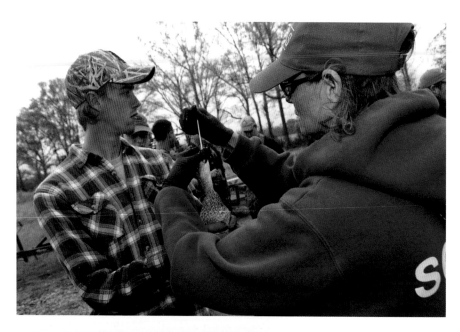

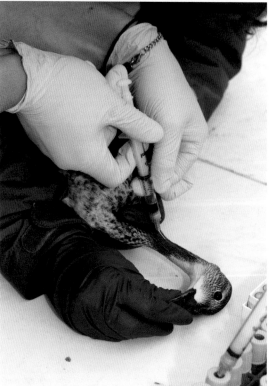

Above: University of Georgia–Athens technician Deb Carter swabs the throat of a blue-winged teal for viruses.

Left: University of Georgia–Athens technicians draw blood from a blue-winged teal.

of volunteers to assist in clearing a net of stressed birds, ensuring there is no mortality.

Link said it takes about fifty bags of corn per site where captures are to be made—plus the cost of equipment, data storage and processing, call center contracts and websites—to band these birds.

"I'm very thankful to go out together with such a great group of volunteers. And I take pride knowing we cleared a net of four hundred–plus ducks and coots in eight minutes with no injuries or mortalities," Link said.

Following capture, the blue-winged teal are immediately banded before the indignities of trachea (throat) and cloaca (posterior opening) swab samples are taken from each bird. After swabbing, blood samples are also extracted before the teal are released back into the wild.

Research technicians like Deborah Carter, from the University of Georgia–Athens, leads a crew that meticulously handles all specimens, placing individual swabs from each bird into test tubes to increase the odds of detecting a virus. Blood samples are spun down for serum, in which scientists hope to find antibodies to influenza viruses. Through blood sampling and testing, researchers are able to learn if the blue-winged teal currently have viruses or if they were previously exposed to viruses by isolating antibodies.

One 2014 USGS abstract pointed out the consistent isolation of H7 subtype influenza A viruses (IAV) during the spring, which provided evidence that the viruses may be relatively abundant in blue-winged teal. What's more, it is a finding that may be important to both public and domestic animal health.

In another report issued by the Centers for Disease Control (CDC) discussing avian influenza A viruses, IAVs usually do not infect humans. Moreover, reported cases of human infection with IAVs are rare. However, human infections with bird flu viruses can happen when enough virus gets into a person's eye, nose or mouth or is inhaled. Yet, the spread of avian influenza A viruses from one ill person to another has rarely been reported and limited, inefficient and not sustained.

The CDC report goes on to say because of the possibility that avian influenza A viruses could change and gain the ability to spread easily between people, monitoring for human infection and person-to-person transmission is extremely important for public health.

Ramsey believes the study of IAVs is complicated:

You hear the word, "bird flu" all the time, but that's a rather broad umbrella. There are a lot of nuances and specific details under that umbrella. And

LDWF biologist Paul Link prepares to release a blue-winged teal.

that's the type of information we're trying to gather. But, it's this sort of information that can be used to improve bio-security for the poultry industry, and we can access the risk of foreign origin of viral threats in the United States.

Hunters sporting prized duck bands on their call lanyards typically equate them to conservation efforts that determine harvest rates, mortality and migration routes of a particular species. And that is true. But the recovery of a blue-winged teal band might just be for the sake of public health.

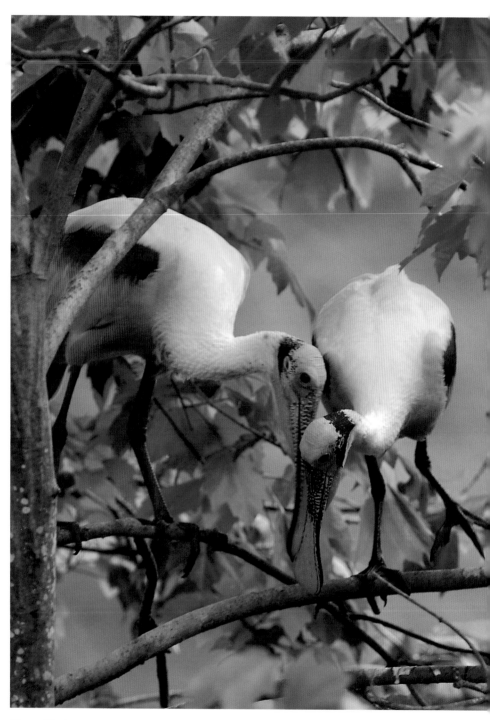

Clown-like in appearance, roseate spoonbills are also spectacularly colored in hues of rich pink and reds, making this wading bird a favorite.

ADVENTURES IN THE NORTHERN AMAZON

Several years ago, I thought to myself, "What would draw thirty-two benefactors from the Cornell Lab of Ornithology to southwest Louisiana?"

The time of year was late February, and although Louisiana is a semitropical climate, the late-winter weather can be wet and chilly. Such was the case during their visit. Nonetheless, as I contemplated the group's rationale, it dawned on me. They were basically looking for all things avian, the abundance of wintering birds the state has to offer—they were just taking advantage of it.

Hosted by Grosse Savanne Lodge, located in Cameron Parish, the group saw firsthand the profusion of migratory waterfowl that winter in the state's coastal marshes and agricultural communities. It's truly awe-inspiring when clouds of snow geese rise above the prairie and a marvel to those who travel to Louisiana.

Essentially, over the course of a few weeks from February to March, as some migrating birds leave, others arrive to take up temporary residency. There are few places in the entire United States where one can be treated to a kaleidoscope of beauty such as the late winter and spring migration in Louisiana.

Waterfowl at this time of the year are in their full mating plumage. Every species of duck is typically paired up by now, and the males are adorned in the most spectacular colors.

Left: Eco tours are available through the lodge each spring and summer. *Courtesy of Grosse Savanne.*

Below: Cornell Lab benefactors on an eco tour at Grosse Savanne.

Mallards are the one duck most people are familiar with in terms of coloration identity. But the green-winged teal, with its rich rusty-reds and streak of green through its eye, is stunning. The blue-winged teal's head displays an iridescent dark blue with a pure white crescent moon that sometimes arches down the back of its head and neck. Even the normally drab gadwall drake, often referred simply as a "gray duck," has a beautiful plumage where some gold wisps of feathers blend into a tapestry of grays, whites, blacks and chestnut colors.

The northern shoveler's green head resembles that of a mallard but with color subtleties. The drake pintail's chocolate- and cinnamon-brown head with magnificent white stripe on top of a grayish speckled body looks better and flashier than a tuxedo from a men's store.

Other wintering ducks include scaup, redheads, canvasbacks, ringnecks and widgeon. Still others include black ducks, wood ducks, bufflehead and ruddy ducks. In all, the benefactors counted thirteen different species on their trip to Gross Savanne.

Public coastal hot spots in southwest Louisiana near Gross Savanne include Sabine National Wildlife Refuge and Cameron Prairie NWR's Pintail Drive. Lacassine NWR is another sure location for wintering waterfowl. But in between these wildlife refuges that rest along the main highways are the back roads—those off-the-beaten-path agricultural locations that provide an abundance of waterfowl.

The Cornell Lab group also came to see yellow rails. This small rail makes the Gulf of Mexico and lower Atlantic states its home for the winter. It is shy and elusive and inhabits the marshes and rice fields of Louisiana. The benefactors actually got an opportunity to see a few when a farmer happened to be manipulating his rice field with a tractor and harrow disc. The birds scooted out of the rice stubble ahead of the tractor, preferring to run instead of fly.

Other rails found along the coastline during the winter are the clapper and king rails, which are year-round residents. Like the yellow rail, the sora rail and Virginia rail are winter migrants to the Gulf Coast.

There is always a flock of sandhill cranes around the L.A. 14 junction with L.A. 27 south of Lake Charles during the winter. In the winter months, the crested caracara is a rare and unusual guest from south Texas and Mexico that is infrequently seen around the agricultural fields owned and managed by Sweet Lake Land & Oil Company, LLC.

Farther south on the coast at the mouth of the Calcasieu ship channel is the town of Cameron. The Cameron Jetty Fishing Pier & RV Park is an excellent location to see shorebirds. A walk on the beach could reveal dunlins, willets and various sandpipers and plovers, which are guests for the winter in this region.

Ruddy turnstones, dowitchers and Wilson's snipe also call the Louisiana coastline home during the winter months.

Toward the end of winter and the transition to spring, which takes place around the third week of March, all of the aforementioned locations in the region are teeming with neotropic songbirds, wading birds and other

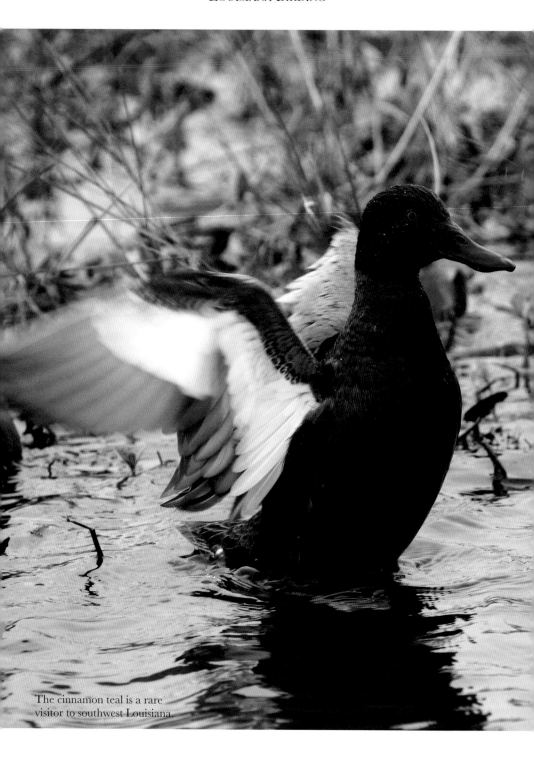

The cinnamon teal is a rare
visitor to southwest Louisiana.

passerines of all sizes and colors. What's more, you'll find many doing the promenade of love at this time of year, particularly wading birds like great egrets.

Yet if one wants to enjoy the dance and joy of the egrets and roseate spoonbills, no place is possibly more captivating than the cypress swamp rookery on Sweet Lake Land & Oil Company property. A morning setting on the rookery can be arranged through the company's Grosse Savanne Eco Tour.

All tours are hosted and guided by Bobby Jordan, Grosse Savanne's Eco Tour manager, who is a McNeese State University graduate in wildlife and renewable resource management. Jordan resides in Little Chenier, south of Cameron Prairie, and worked for Sweet Lake Land & Oil Company while attending college. One of his summer projects was developing and building a six-hundred-acre lake impoundment designed for freshwater fish that also served as a habitat for wading birds and waterfowl. Additionally, it is an ideal stopover location for migratory birds returning from their Central and South American winter residence to their North American breeding grounds.

Jordan has built blinds in the cypress tree rookery for guests to sit and enjoy nesting roseate spoonbills and greater egrets. The blinds are breathtakingly close to rookery nests, where photographic opportunities are excellent.

Anhinga.

Roseate spoonbill.

Guests have the choice of two-hour, half-day and full-day tours. A lunch is provided for longer tours, and Grosse Savanne attempts to meet the needs and desires of each individual or group—like the Cornell benefactors.

Grosse Savanne has a five-star lodge, but eco tours are available for non-guests as well. There are packages where birdwatchers and nature lovers can drive up and meet Jordan at the crack of dawn.

My spouse and I spent one Saturday morning sitting in a blind overlooking a cluster of cypress trees with several roseate spoonbill nests. The beautiful birds were in fashionable reddish-pink breeding season colors. Their long, pale-green, clown-like bills didn't seem to detract from their beauty.

In spite of their size, twenty-eight to thirty-four inches long, with forty-seven- to fifty-two-inch wingspans, they are relatively lightweight at only 2.6 to 4.0 pounds. Several times, these grand birds flew into the branches of the trees we overlooked. They walked along the branches with ease and comfort that would make any of the Flying Wallendas amazed.

The time of spring you visit the cypress rookery will determine what stage of nesting or feeding young is taking place. We observed great egrets feeding their young while roseate spoonbills were building their nests.

Above: Beautiful Grosse Savanne Lodge.

Right: The lodge offers a comfortable setting on the coastal prairie.

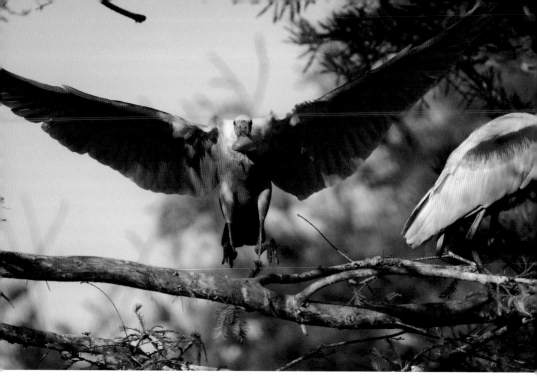

Roseate spoonbill.

Cornell Lab's executive director John Fitzpatrick, who accompanied and led the group of supporters, was quoted as saying,

> *More broadly speaking—the Mississippi Delta region is the Amazon of North America. It's a major system of rich productivity. And, to lose square miles a day of this habitat to ocean basically, it seems we're losing habitat and losing opportunity for these things* [birds] *to survive....We have the things that migrate down and spend the winter here. And we have the things that are about to use this land as they come back from South America and land here before moving on north. They need good habitats out here to be able to survive. And as we lose habitat we're going to lose birds.*

Like much of Louisiana's coastline, southwest Louisiana's chenier plain has struggled with erosion as well. The Lake Calcasieu ship channel has allowed salt water to enter into the marshes and wetlands surrounding the lake.

In November 2017, the Coastal Protection and Restoration Authority announced it was entering the engineering and design phase of the Calcasieu Ship Channel Salinity Control Measures project under the

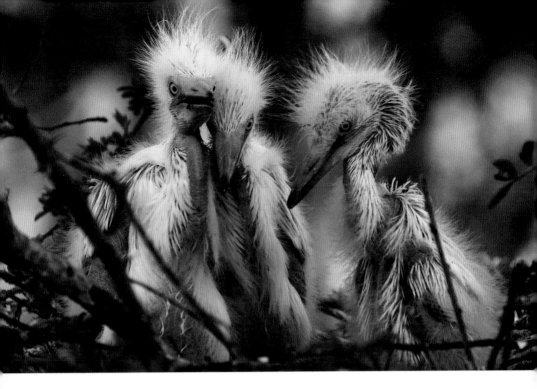

Hatchling great egret chicks.

Direct Component of the RESTORE Act. The Federal Department of the Treasury released $9.6 million in funding toward this phase of the project, designed to manage the salt water that has been infiltrating the lake and causing habitat loss in the surrounding wetlands.

The region is an important and critical habitat for all species of birds. Louisiana's coastal estuaries winter countless species of shorebirds like sandpipers, plovers, gulls, terns and black-necked stilts, along with wading birds and waterfowl. Huge flocks of white pelicans make coastal lakes and bays their home at this time of year. Along the beaches are willets, sandpipers and ruddy turnstones. And neotropic songbirds make the remaining chenier plains their first stopover when migrating across the Gulf of Mexico.

Louisiana's coastal bayous and marshes have such vitality and beauty that's teeming with birds and wildlife. Fitzpatrick was right to refer to it as the Amazon of North America. There perhaps is no better place than coastal Louisiana to experience adventure.

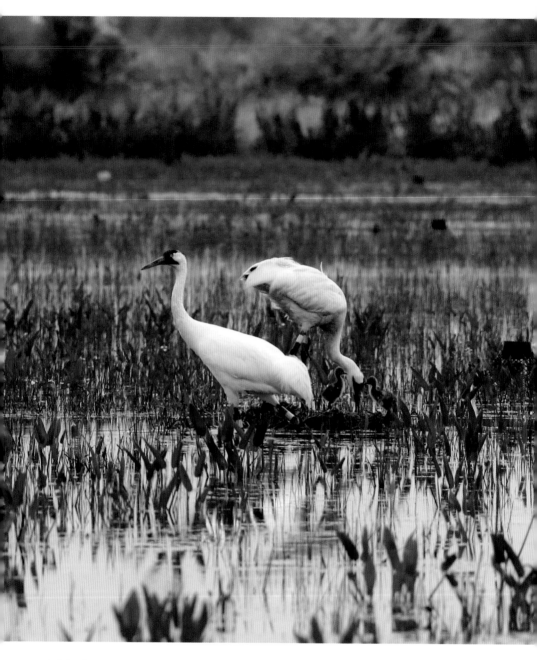

Adult whooping cranes with hatchlings on the prairies of southwest Louisiana.
Courtesy of the Louisiana Department of Wildlife and Fisheries.

12

REINTRODUCTION OF WHOOPING CRANES
CONTINUES IN LOUISIANA

*I*n 1939, when John J. Lynch flew over the southwest Louisiana marshes, very near to where White Lake Conservation Area is today, the U.S. Bureau of Biological Survey biologist counted thirteen whooping cranes. By 1949, one crane remained on the landscape.

Captured in 1950, the lone bird was transported to Aransas National Wildlife Refuge near the Texas Gulf Coast—an area known to hold one of the last migratory whooping crane populations in North America. Loss of habitat and hunting had taken a toll on whooping crane populations nationally and only a handful, from what is estimated at ten thousand birds in the mid-1800s, remained.

It had been over sixty years since whooping cranes graced the Louisiana coastline. However, in 2010, that all changed as a result of a joint Louisiana Department of Wildlife and Fisheries and U.S. Fish and Wildlife Service effort to reintroduce these majestic and endangered birds as a nonessential experimental population (NEP).

The USF&WS designation NEP meant, based on the best available information, the experimental population was not essential for the continued existence of the species. Therefore, regulatory restrictions could be vastly reduced.

This was important in order to establish relationships with landowners in the agricultural rice fields and crawfish pond areas of southwest Louisiana. The great birds, standing nearly five feet in height with a wingspan of some seven and a half feet, would be protected under the guidance of

Whooping cranes were once hunted by both market and sport hunters. *Courtesy of the North Dakota Department of Game and Fish.*

the Endangered Species Act, wherein the "take" of wildlife is defined as harass, pursue, hunt, shoot, wound, kill, capture, collect or attempt to engage in any such conduct and prohibited. But the reintroduction would not affect activities undertaken on private lands unless they were authorized, funded, permitted or carried out by a federal agency.

In short, under the Endangered Species Act experimental rules, the department would have much more leeway to take local concerns into account when preparing the management strategies and thus avert restrictions on current and future land uses and activities.

In 2004, British Petroleum donated seventy-one thousand acres of marshland above White Lake to the State of Louisiana. Since acquisition of the property known as White Lake Conservation Area, it has been utilized for agriculture, oil and gas production, hunting, fishing and a variety of non-consumptive actives such as birdwatching, education and research.

What's more, because of White Lake's historic association with whooping cranes, its vast acreage and the ability to manage its hydrology, the refuge lends itself to being perhaps the most suitable habitat for reintroduction of the species in the South.

LDWF biologist and wildlife outreach coordinator Carrie Salyers has been involved in the reintroduction program since the first cohort arrived in February 2011.

Salyers said whooping cranes are finicky in terms of the amount of water they like, especially when it comes to nesting, roosting and the habitat they prefer. Because the department had the capability to manipulate and control water levels in certain areas of White Lake, there was a good chance that whoopers could be established.

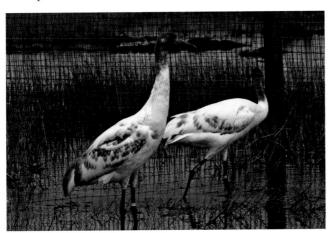

New arrival whooping cranes are acclimated to White Lake Conservation Area and temporarily kept in holding pens before release. *Courtesy of the Louisiana Department of Wildlife and Fisheries.*

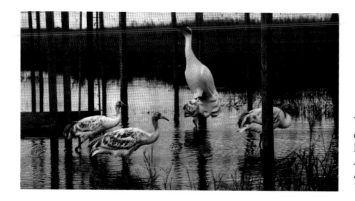

Young whooping cranes on White Lake Conservation Area. *Courtesy of the Louisiana Department of Wildlife and Fisheries.*

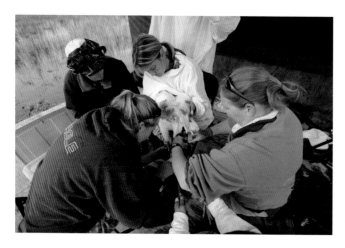

LDWF biologists and technicians band and install telemetry units on young whooping cranes. *Courtesy of the Louisiana Department of Wildlife and Fisheries.*

Banded whooping crane.

With only two main migrating whooping crane populations in North America (the Wood Buffalo Park Canada to Aransas NWR, Texas population and the Necedah NWR, Wisconsin to Florida population) and one non-migrating population in the Kissimmee Prairie area of central Florida, a real potential existed for large losses of the species in the event of natural or manmade disasters. Spreading the birds out could prevent the possibility of that occurring.

The non-migrating population of whooping cranes reintroduced by the USF&WS in the Kissimmee Prairie region has struggled with habitat conditions, reproduction, predation and even impact trauma with things such as powerlines. Some 289 captive-born, isolation-reared whooping cranes were released into Osceola Lake and Polk Counties in an effort to reestablish the non-migratory flock.

The last releases took place during the winter of 2004–5. As of November 2010, only twenty-one individuals were being monitored, including eight pairs.

LDWF biologists felt Louisiana really fit the bill as far as habitat and food requirements were concerned for the species. By establishing a non-migrating Louisiana population, officials perceived they were getting all of their eggs out of one basket, so to speak, by not having all whooping cranes in one or two places should a natural or manmade disaster occur.

Salyers asserted that the birds are wild animals, and it is important to let nature take its course if they are to establish themselves. Whooping cranes are omnivorous; therefore, food sources shouldn't present a problem for them in the coastal marshes surrounding White Lake. The birds feed on a variety of invertebrates such as insects and crawfish but will also eat blue crabs found near the coastline in addition to aquatic vegetation, berries, acorns and waste grains.

As of this writing, the program is in its eighth year. Through 2017, 125 have been released, with a 54 percent survival rate. Of the "known" causes of mortality, 10 were due to predation or suspected predation; 11 were due to gun shots; 8 were caused by impact mortality; 5 were attributed to illness or injury, where in some cases the cause was due to bumble foot (a bacterial infection and inflammatory condition leading to swelling of the feet and toes); 2 were due to other illness; and 22 causes of mortality were attributed to disappearance, where birds were categorized as missing or presumed dead.

For example, in 2016, two male whooping cranes migrated north with sandhill cranes. Department officials were able to track one of the two. Only one of the cranes returned, without his companion.

In 2016, in Jefferson Davis Parish, Louisiana had its first chicks hatch since they were extirpated from the landscape in 1950. One of the chicks survived one month and the other only until the following fall. Still, LDWF biologist Phillip Vasseur said it was a positive sign that both chicks fledged.

In 2017, three chicks were hatched. Two of the eggs were fertilized eggs accepted by a nesting pair of whooping cranes. One chick hatched and survived only two weeks. A second egg of their own hatched naturally, and the chick survived one month before disappearing. The third egg (fertilized and placed in the nest artificially) was designated as LW-3-17 and is still alive, living on its own, and the parents are no longer caring for it.

A 2014 synopsis of nesting whooping crane pairs revealed there was one pair that nested twice, indicating one re-nest effort. In 2015, there were four pairs that made five nests. In 2016, five pairs made nine nests, with the first ever successful nest. And in 2017, eight pairs made eighteen nests, producing three chicks (one natural and two fertilized eggs placed in the nest).

Vasseur said the department expects to learn a lot over the next five years, as the Louisiana population is young, making it hard to draw conclusions on reproductive rates. "It's a long-lived species that is slow to reproduce.... It takes patience."

Essentially, biologists feel it may take years before success of the reintroductions can be measured to any large degree. Beyond acclimation periods, the birds have to mature and reach breeding age and face obstacles such as predators, disease, injury and the fact that they produce few young.

It takes three to five years for whooping cranes to reach sexual maturity. And they typically lay only one or two eggs, seldom raising two chicks. By comparison, other large wading birds like egrets produce three or four young a year.

Necedah NWR biologist Brad Strobel said the migrating Wisconsin crane population, now over one hundred birds, seems to be doing fairly well. The birds are migrating and are able to select habitat that seems appropriate to them. The released trans-America eastern population, which once migrated to Florida, has individuals wintering in Indiana, Kentucky and Tennessee.

If there is a problem, Strobel noted that the population is still not reproducing very well. What's more, biologists still haven't cracked the code as far as reproduction is concerned.

One of the biggest setbacks for the Louisiana population has been shootings. The last living individual from the first release was a male that was shot with a female on February 7, 2014. The pair had demonstrated

courtship activity the year prior, and all indications pointed to potential nesting during the upcoming year.

Though there have been eleven whooping crane shootings in Louisiana, the problem has also occurred in other states. Seventeen whooping cranes have been shot in the past decade nationwide. The problem has state agencies looking for solutions.

Florida's non-migrating population, once 289 birds, has declined to 21 in recent years. With high mortality and low productivity, the population is no longer being supplemented with young birds but will continue to be monitored. However, in March 2018, the USF&WS was in the planning stages and public comment period to move 14 whooping cranes from this population over to Louisiana.

Louisiana has become the focus and is at the forefront, with the light shining on the state, hoping for success. Florida is the most comparable project for what the USF&WS is trying to do in Louisiana. The LDWF has set a goal of trying to establish a population of 120 to 132 whooping cranes, with 25 to 30 breeding and nesting pairs.

Salyers maintained that the department is not deterred from the initial struggles experienced since the first reintroductions, nor are the many supporters, including conservation organizations, private donors and waterfowl hunters from around the country who wish to see the Louisiana reintroduction project a success. With support like that, it's just a matter of time before whooping cranes will grace Louisiana's landscape again.

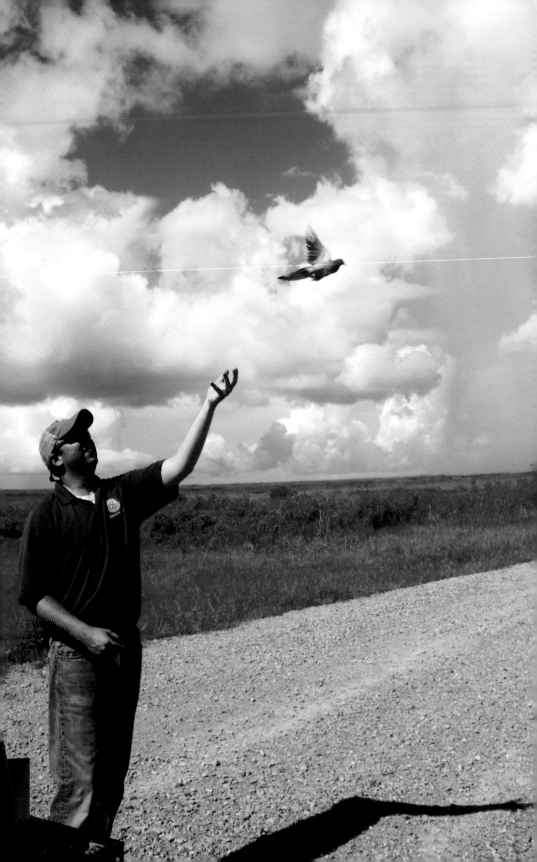

13

LOUISIANA DOVES

*J*ames Whitaker, a waterfowl biologist for the Louisiana Department of Wildlife and Fisheries, turned his truck onto an oil field service road on a hot, humid August morning in 2017. For years, the road was utilized by Chevron Corporation and provided access to one of the company's well locations on Rockefeller Wildlife Refuge in Grand Chenier, Louisiana.

The company has long since removed its production equipment, and the remaining pad in the refuge's marsh now makes an excellent capture site for banding mourning doves.

Coming to a stop a short distance from the location, Whitaker picked up his binoculars and glassed twenty-one walk-in traps made from vinyl-coated square wire mesh. The traps were baited just after daylight, and at the time, the biologist was making his first run of the morning.

Since 2003, when the National Banding Program for doves was initiated, Louisiana, like most states in the lower forty-eight, has participated in the effort annually during July and August. Louisiana happens to be part of the Eastern Management Unit; of the twenty-seven states, nineteen hold annual dove seasons.

The objective, said Whitaker, with any migratory game bird is typically learning survivorship and estimating population densities of resident birds. Biologists also look at band recovery rates and their locations, which can provide them with migration patterns.

Opposite: LDWF biologist James Whitaker releases a mourning dove.

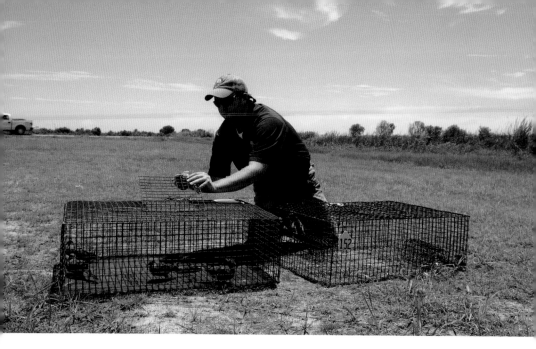

Above: LDWF biologist James Whitaker removing mourning doves from traps.

Opposite: LDWF biologist James Whitaker checks traps.

Since the program's beginning through 2017, 268,167 doves have been banded in the Eastern Management Unit, 225,912 in the Central Management Unit and 102,474 in the Western Management Unit. Band recovery numbers over the same period are 17,057, 12,386 and 4,317, respectively. According to Whitaker, some of the doves he personally banded have been recovered and reported from as far away as Mexico.

Louisiana recognizes seven species of dove. They are the mourning dove, white-winged dove, Eurasian collared-dove, ringed turtle-dove, common ground-dove, Inca dove and the rock dove (a.k.a rock pigeon or common pigeon). Of the seven, two hold protected status: the Inca dove and the common ground-dove. By far, mourning dove are the most populous.

Whitaker, originally from Arkansas, had previous experience banding doves, something the biologist says he's always enjoyed, prior to coming to the LDWF. He has been banding doves on Rockefeller Wildlife Refuge since 2014 and learned a number of things over the past several years. In particular, the doves he banded on Rockefeller appear to be staying in the region year-round because of the number of recaptures from previous years.

The biologist said mourning dove on the chenier plain have everything they need to survive. Therefore, though some do migrate, there is little need for them to do so.

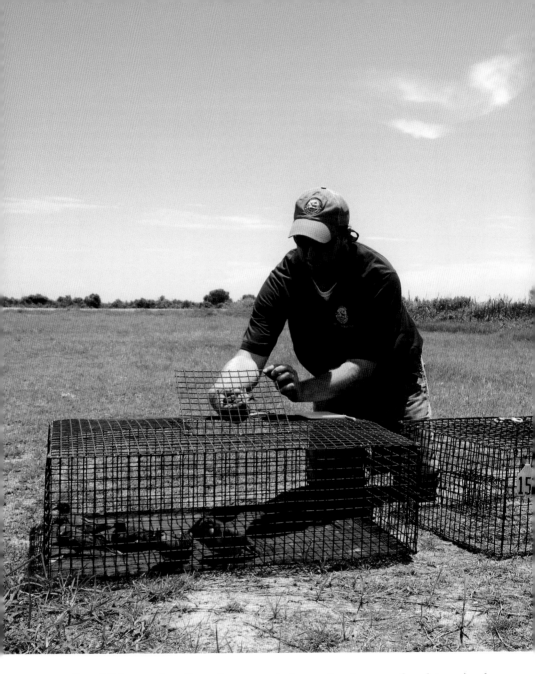

In addition to banding, dove population estimates are also determined by spring breeding bird surveys. During the month of May, biologists and volunteers count every dove seen or heard cooing (Coo Call Survey) along fifty stops in a twenty-four-and-a-half-mile-long route. Each stop is three minutes long. In Louisiana, there are nineteen randomly selected routes across the state.

Left: LDWF biologist James Whitaker bands a mourning dove.

Opposite, top left: A banded mourning dove.

Opposite, top right: Biologists check age and sex of doves following capture.

Below and opposite bottom: LDWF biologist James Whitaker studies best feeds.

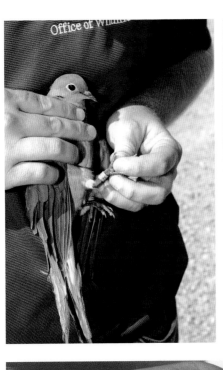
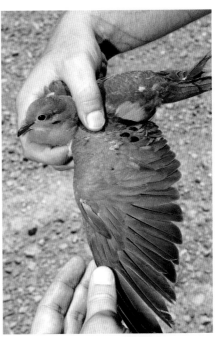
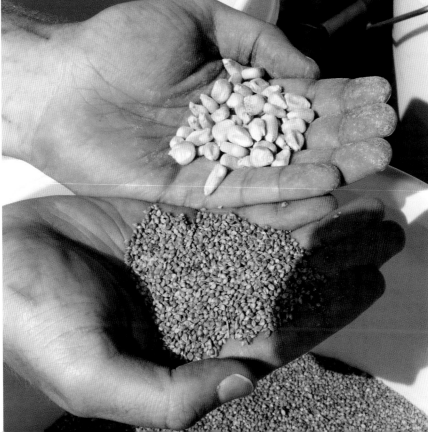

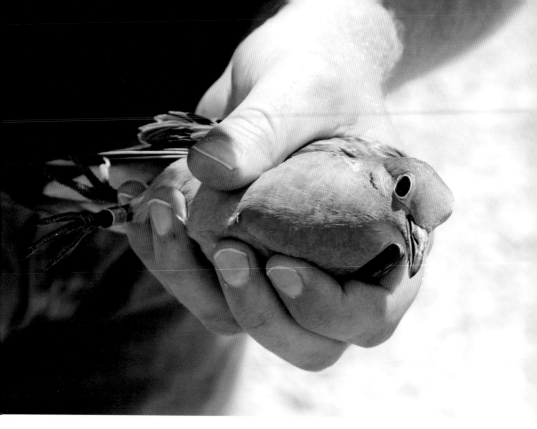

Banded mourning dove.

Other information used to complete USF&WS population studies are random hunter surveys known as the Migratory Bird Harvest Information Program (HIP). Additionally, there is an annual "wing bee," where wings of harvested doves are counted and reviewed for sex and age.

Essentially, all of this data collecting helps wildlife managers in the development of harvest strategies to ensure the long-term conservation of mourning dove populations and minimize frequency of regulatory changes. As of 2017, the total dove population numbers appear to be 279 million nationwide.

The Eastern Management Unit mourning dove population is considered stable and to have increased over the last fifty-one years to approximately 62.3 million, whereas the Central and Western Management Units have declined, but not in the past decade.

In 2017, Whitaker also tried to determine what type of seeds dove happen to prefer. Whitaker said one year he used milo because it was considerably cheaper, but his trapping success was reduced. In an effort to save the department money and increase his trapping success, traps were baited with

either whole corn, cut corn, milo and Chinese or Japanese millet. Chinese and Japanese millet had the highest capture success.

Mourning dove can be found in all of the lower forty-eight states, and a few have appeared in Alaska. Hawaii, where mourning dove were introduced, has a small population. They are a migratory bird that holds both game bird and songbird status.

The mourning dove coo is perhaps the most recognized call of any bird. It's low, soft, lingering tone carries aloft in the peaceful morning quiet before sunrise. Every backyard feeder will attract mourning dove. Their gentle nature makes them a welcome guest to all.

The spring cooing surveys, the Harvest Information Program and the National Banding Program are federal and state efforts that go on quietly behind the scenes. And it's the way wildlife agencies throughout the country maintain vigilance on this popular bird.

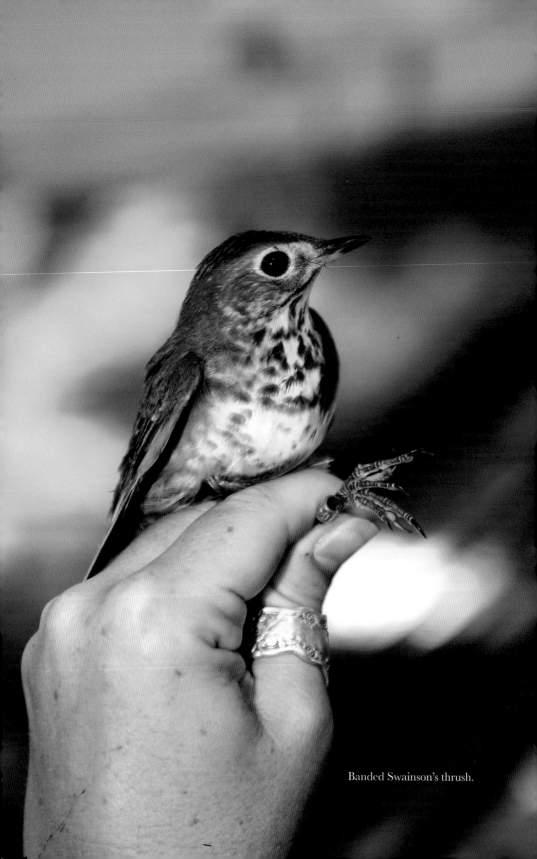

Banded Swainson's thrush.

NANOTAG STUDIES HELP BIOLOGISTS LEARN MORE ABOUT COASTAL CHENIERS

A drive down Grand Chenier Highway during rush hour is nothing like traveling in New Orleans at first light. In this remote region of southwest Louisiana, the closest thing to being in a hurry are the bird banders and mist net assistants making rounds under the beautiful old-growth, tree-lined cheniers during the annual bird migration. Historically created by the floodwaters of the Mississippi River, where the Gulf of Mexico met land through open channelization, these small ridges, or cheniers, are basically endangered today.

Samantha Collins, a biologist who has worked for the Louisiana Department of Wildlife and Fisheries on Rockefeller Wildlife Refuge since 2014, earned her master of science degree in wildlife and fisheries from Clemson University in 2012. Prior to being offered a graduate research assistantship at Clemson, whereby eventually earning her master's degree, Collins said she bumped around several states as a technician trying to learn all she could.

Following her master's program, the young biologist ultimately wound up at the United States Geological Survey's Bird Banding Laboratory at the Patuxent Wildlife Research Center in Maryland, where she recorded band data. According to Collins, it was all good experience preparing her for the research work she has been conducting on Rockefeller.

For approximately twenty years, the University of Southern Mississippi, under the direction of Dr. Frank Moore, operated a migration station in Johnson Bayou, Louisiana. Located some sixty miles west of Rockefeller

Refuge, along the Gulf Coast near the Texas border, the station was just one of several that acted as study and research locations, where biologists and technicians record every bird they hear, see or catch in mist nets. The data obtained provide critical information for the development of habitat management strategies and determining the health of avian populations.

In more recent years, cattle grazing began to alter the landscape on the Johnson Bayou site, causing it to somewhat decline as a research location. About that time, Collins had come on board with the LDWF. Stepping in, she contacted Moore to offer the Nunez Woods property across the road from the refuge to continue the important migration research.

The Nunez Woods property happened to be an old growth chenier, with rich stands of pristine live oak and hackberry trees that is leased by the department for research purposes. In short, the offered site is perfect for migrating songbirds. Subsequently, in 2015, Collins was able to work with Moore, and funding was obtained to operate a migration station that year.

As it turned out, 2015 proved to be very successful, and the Nunez property produced lots of birds according to Collins: "It was a very productive site. We caught a lot of birds and there was even some species like Swainson's warblers that we caught more of on Nunez than they had ever caught at Johnson Bayou."

In 2016 and 2017, there were no funds available to operate the migration station on Nunez Woods. But, in 2018, a couple of critical research projects came up, including one measuring the tick load of migrating birds—studies show birds often carry these parasites. The other study was comparing weather radar migration data with actual information from migration stations on the ground.

In addition to the Nunez Woods site, down the road, the Nature Conservancy manages a conservation easement it negotiated with landowners to support wildlife, particularly migrating birds. Known as the Hollister Chenier Preserve, the property is roughly fifty acres in size, and by comparison, it is newer succession growth, consisting mainly of lower canopy woods and shrub understory.

Having both chenier habitats close by is ideal for Collins and the research she is involved in with the department. Coastal erosion, hurricanes and land use have all reduced the available chenier acreage along the coast to a fraction of what it once was on the coastal prairie.

Opposite: Motus telemetry antenna.

NanoTags.

One of the studies Collins is involved in is looking at the value of the remaining cheniers to songbirds. The study requires the biologist to look at the vegetation composition and conduct fruit sampling as well as sampling arthropods to determine what prey is available in the form of insects, arachnids, myriapods and crustaceans.

Collins is also involved in the Motus Wildlife Tracking System program currently managed through the Louisiana Natural Heritage Program arm of the LDWF. *Motus* is Latin for "movement" and is an international collaborative research network that uses a coordinated automated radio telemetry array to track the movement and behavior of small flying organisms, such as birds, bats and insects.

Essentially, signals from tiny avian NanoTag transmitters are emitted to antenna arrays located along the coastline that track migrating birds as they fly overhead. Signals from NanoTags can be detected ten to fifteen kilometers (six to nine miles) away. The only drawback is the antenna towers cannot detect birds down on the ground or obscured by vegetation.

One of the things Moore has looked at is the availability of suitable habitat where energy stores critical to a successful migration can be safely deposited.

In Collins's NanoTag research, she has chosen Swainson's thrushes and northern water thrushes. Her reasoning is that both of these species are northern latitude birds capable of traveling long distances during the spring migration. And, by the numbers of them caught at the Nunez Woods migration station in 2015, they would be good candidates to study the importance of chenier habitats as key stopover locations for them to rejuvenate during migration. She explained:

> *We're looking at their age class and their condition. We're looking at their fat and muscle scores. We want to know if a low fat, low muscle bird takes longer to migrate north, or would they stay here longer to refuel. Or, would fatter healthier birds get up there quicker. Those kinds of questions we really haven't been able to ask before. Essentially, songbirds rely on these chenier habitats to refuel. And, if they can't make it to their northern habitats to breed, then populations are going to suffer because of that.*

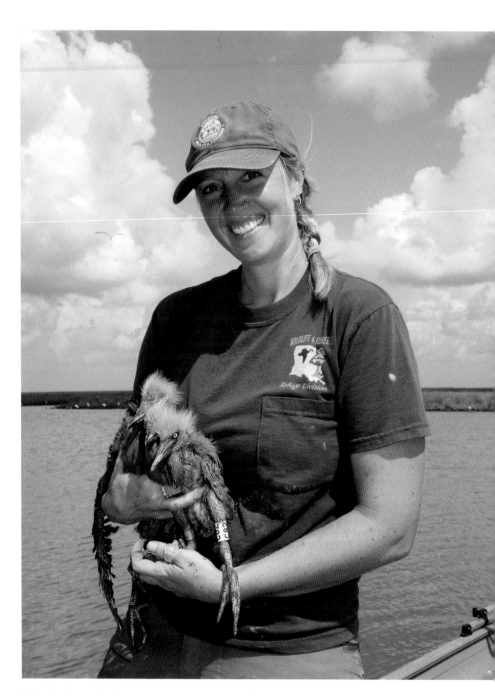

Biologist Samantha Collins with reddish egret chicks.

LEARNING MORE ABOUT REDDISH EGRETS

For several seconds, biologist Samantha Collins intently studied the weight on her Pesola spring scale. Hanging from the instrument, nestled in a soft mesh cotton sack was a reddish egret chick, just weeks old. When the scale settled on 590 grams, Collins smiled and gently spoke to the bird: "You're a real fatty aren't you?"

Getting the chick's weight was just one of several measurements the biologist meticulously obtains while gathering data on this particular species. Other measurements include the culmen (upper beak or bill), tarsus (leg bone) and wing length—all of which are critical in understanding the health and growth of reddish egret young.

A member of the Ardeidae family of birds, which includes bitterns, egrets and herons, the reddish egret is listed as a species of greatest conservation need in the Louisiana Department of Wildlife and Fisheries' Wildlife Action Plan. In fact, the species is ranked as an S1. In the plan's explanation of rankings, S1 is defined as "Critically imperiled in Louisiana because of extreme rarity (5 or fewer known extant populations) or because of some factor(s) making it especially vulnerable to extirpation."

Collins, who works for the LDWF out of the Rockefeller Wildlife Refuge office in Grand Chenier, has led the department's efforts to learn more about this rarest of heron species since 2015.

She noted:

> From some of the surveys we've done, it appears that reddish egrets are in very low numbers throughout the state. And, we really don't know much about them. We don't know where they're selecting nesting habitat, or on what islands....One big question we have, is what foraging habitat do they use? So, we did a little bit of a pilot study in 2015....We had Dr. Clay Green, a professor at Texas State University come out here to southwest Louisiana to talk to us about what they've been doing in Texas. We had him show us some trapping techniques, show us how to bleed birds for genetic analysis, and learn how to attach transmitters to them.

Collins's team utilizes 17g Solar Argos/GPS PTT Transmitters. Weighing just seventeen grams, the solar-powered platform transmitter terminals have been invaluable in collecting important data that researchers need to better understand reddish egrets. Further, by altering a self-tripping trap design by University of Florida research professor Peter C. Frederick used to capture colonial nesting birds, Collins has been able to successfully place transmitters on the adult birds she is studying.

As a rule, only healthy birds receive transmitters and only when the transmitter is less than 3 percent of the subject's bodyweight. Geographically, Collins uses Point Au Fer Island along the central Louisiana coastline to basically divide the state into two study regions. Currently, she has eleven transmitters deployed in the southeast on adult reddish egrets and twelve transmitters in the southwestern part of the state.

Population size and survival rates are extremely important to biologists. Therefore, learning what a certain species' limiting factors are is crucial. Now in her third year studying reddish egrets, Collins noted the department's efforts have garnered important data that have helped answer some questions but raised others.

Most of the data Collins collected have been obtained by studying reddish egrets on Rabbit Island, located in the southwest corner of Lake Calcasieu near Lake Charles, Louisiana. One of the things the department has learned about reddish egrets nesting on this island is they don't have to go very far to forage compared to birds nesting on the eastern side of the state:

> Reddish egrets are looking for something in particular. It's one of the things we're starting to see on Rabbit Island. What we've learned from the data so far is, all of the birds that have transmitters don't go very far to forage.

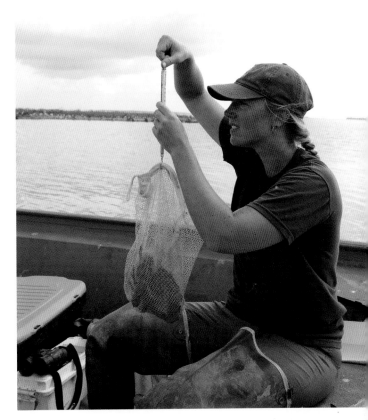

Right: Collins weighing a reddish egret chick.

Below: Collins measures the culmen of a reddish egret chick.

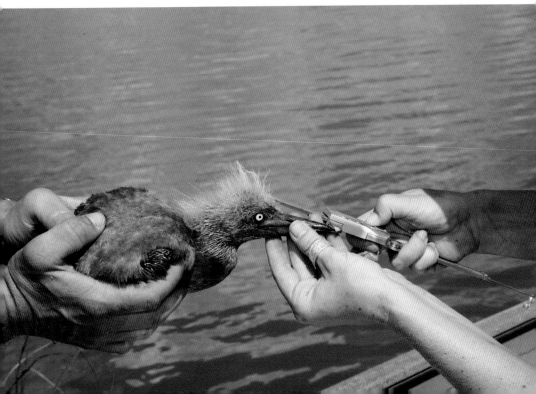

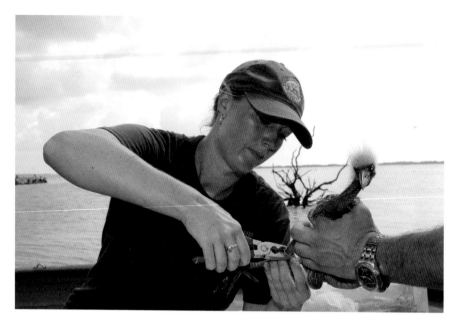

Collins bands a reddish egret chick.

Parasitic worms found in food could be one of the limiting factors biologists are looking for in learning more about reddish egrets.

The majority of birds on the west side of the state are sticking around. There's a lot of good foraging habitat around Sabine National Wildlife Refuge and Apache Louisiana Minerals land and these areas have nice clear shallow water.

Though two of the Rabbit Island birds Collins placed transmitters on made trans-global migrations, going as far as Guatemala and Nicaragua, reddish egrets are considered semi-migratory, the biologist said. She pointed out that it's not uncommon for them to make movements down the coast to Mexico.

By contrast, the eastern birds Collins trapped and placed transmitters on—on Raccoon, Brandy and Queen Bess Islands—make very large movements between nesting and foraging areas.

Collins, who is heavily involved in the REEG Working Group, which established the Conservation Action Plan for the species and is currently the leader for the research and monitoring committee, said, "They have certain areas they are looking for, especially where foraging is concerned. Over by Grand isle, nesting islands are located within a bigger bay system not ideal for foraging, which could be one of their limiting factors there."

One of the things Collins does without hesitation is collect the vomit from the chicks she handles during banding. The regurgitation is somewhat commonplace during the handling process according to the biologist and provides significant additional data.

"While we were banding the chicks, we saw a lot of them regurgitating, so we said, 'Let's collect that regurgitation and compare what they're actually eating to what we collect from the foraging habitat sampling points.' Once we started analyzing samples we noticed a good number of the samples had these little worms in them," Collins said.

The worms turned out to be parasites using the fish as secondary hosts. When the birds consumed the fish provided by their parents, they became the primary host. Taking measurements and recording what the chicks eat and notating the condition of their health could provide answers to yet another potential limiting factor.

Collins noted that she gets her greatest satisfaction from the amount of information she's been able to collect so far from the important study. Considering the department didn't know much about reddish egrets in the state of Louisiana, it's significant. But there's still much more to learn.

A mother's love.

MY SUMMER WITH ELIZABETH

And just like that…she was gone. What can you say? Some relationships aren't made to last, so it didn't come as any surprise. But there's no doubt looking back at that summer long ago, through the emotions I felt and the things we shared, I somehow came away a better man.

It was late May when I first saw her from afar, but I immediately knew she wasn't going to be mine. No, she had more handsome suitors—flashier, more cosmopolitan. After all, she had traveled and arrived here from somewhere down south, perhaps Mexico or Central or South America only days before.

These guys who surrounded her could dance and sing like Ambrosia— "Biggest Part of Me" and "You're the Only Woman." Why is it that chicks dig the guys with moves on the dance floor? I suppose it's because the rest of us become like old routines.

But then, who can compete with the inspiration for Lionel Ritchie's "All Night Long?" "People dancing in the streets, see the rhythm all in their feet, life is good, wild and sweet."

I was enamored with Elizabeth. And my wife was no more jealous than she was when our lab, Brie, was just a pup. Mornings and afternoons with the workdays in between were spent tossing training dummies for months. Her only comment was, "Before you go out and play with your girlfriend, you better come inside and kiss me first."

So it was with Elizabeth for a few months. Chris would sagaciously call my cell to inquire whether the afternoon commute home was going to include a

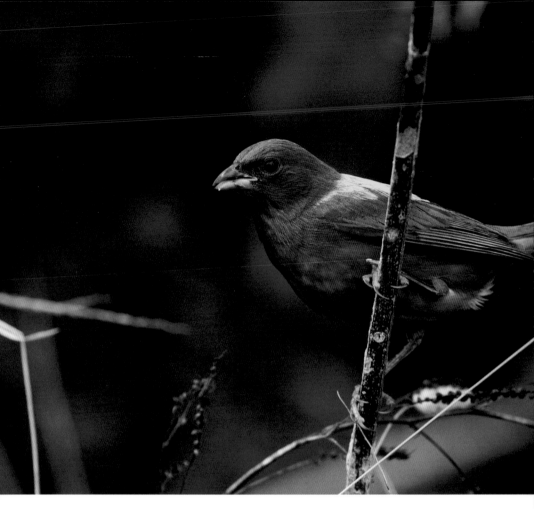

Male painted bunting—Elizabeth's suitor.

stop by a sugar cane field with some early successional growth that bordered Bayou Teche National Wildlife Refuge first.

She knew me too well. Being smitten can't readily be hidden. So, with plenty of evening light after work thanks to daylight saving time, I'd be late for another supper.

Once Elizabeth had chosen her mate, who was handsome, gallant and monogamously attached to her, she went about constructing a nest. I knew the brood of these painted buntings would be a blessing to the world. A certain rabbi foretold of such things and, like us, their importance to his father.

In a span of seven short days, she securely fixed the birthplace of her chicks along the limb of a red swamp maple where it forked off the main

176

trunk. Inside the bowl built from flag grass, assorted leaves, bits of spider web and mud to bond it together lay three eggs.

Each evening before sunset I'd visit, like a doting grandfather. Watching from a distance and taking my pictures from afar, so as not to disturb her, I became lost in my thoughts and anxieties.

"What if a hawk sees her or a snake slithers up that tree?" I'd worry. Where she lived, there are no streetlights, no law enforcement or neighbors watching. Nature can be cruel.

Visits during those afternoons were more to give myself peace of mind. She was fine. Her yellowish-green color and nest blended in so well that most creatures, including humans, could walk within inches of her and never notice she was there. If she was afraid, her stillness demonstrated her courage.

Like a steady wave, the low buzz of cicadas joined a chorus of songs from common yellow throats that seemed to always sing when no other birds feel like it. Elizabeth's mate sang joyously from a nearby willow. And through my lens I saw them—first two, then the third. She had hatched her chicks.

They looked too fragile for this harsh environment.

But the birds in the surrounding brushy woods all sang anyway, regardless of the dangers that were present. This was their lot in life. They seemed unimpeded or concerned with such truths and went about their business in spite of the facts.

What was it, eight or nine days? In just shy of three weeks, I saw this miracle of nature.

As voluptuous as Elizabeth was during her courtship, she possessed the maternal instincts revered by humankind. She would leave the nest for merely seconds and return to gaping mouths with insects, caterpillars and huge garden spiders whose webs block wooded trails and give those who pass the creeps.

Whole they swallowed the protein raw and, in most cases, still wiggling. Again, nature is cruel, and these baby buntings had little time to grow, perhaps eight or nine days, before a predator would eventually discover their hide.

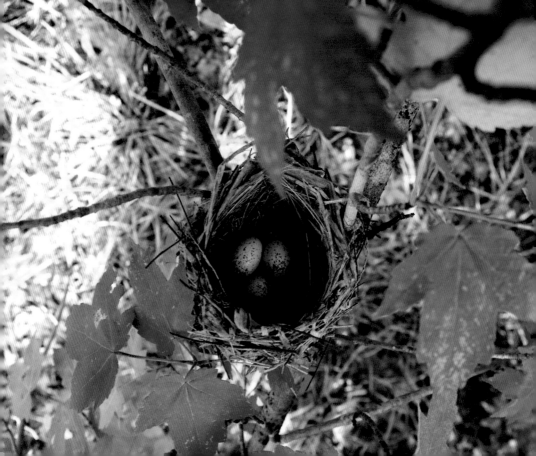

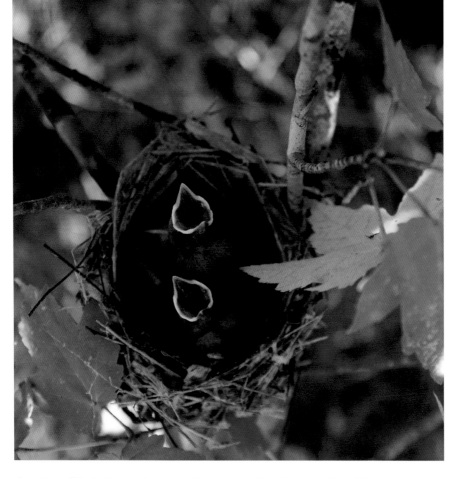

Opposite top: Elizabeth starts her nest; *Opposite, bottom*: Bunting eggs; *Above*: Mouths to feed.

They say one dog year equals seven human years. If so, then one bunting's day in the nest must be equal to two or three human years because these guys fly or die in just over a week. And by the end of August—or early September—the whole brood will fly south over the Gulf of Mexico to the tropics for the winter.

At the end of summer, I stood alone along the trail where Elizabeth's empty nest remained in the low branch of the maple. Some other mother hoping to trap an unsuspecting insect for supper had already strewed cobwebs across it. Somewhere in the understory of the surrounding wooded acreage, she was out there with her young fattening up, preparing for the first northerly winds to whisk them all across the sea.

There are things that shape your thoughts over the course of life's journey. My summer with Elizabeth has left an impression on me that I'll carry forever. So much so, that next spring, I waited for her along the trail.

EPILOGUE

Who can live without birds? They are conspicuous creatures that tell us about the health of our environment. They bring joy to the masses through their beauty and songs. And, where game birds and waterfowl are concerned, they even provide a source of food.

Dick Wilberforce, a renowned wildlife photographer who lives in Canadian, Texas, and someone whose photographs have appeared on over 150 covers of national magazines, once said to me, "It wasn't the Winchester that won the west. It was the lowly prairie chicken that fed the pioneers who traveled the expanse of the plains."

Each spring, the octogenarian Wilberforce guides numerous groups of nature lovers, birders and photographers to a blind on a private ranch overlooking a lek just before daylight to enjoy the mating dance and vocal booming of lesser prairie chickens. During our morning adventure, Wilberforce and I visited on the merits of clean energy, particularly wind turbines.

At the time, the Texas panhandle prairie was loaded with oil field equipment from hydraulic fracking. We happened to drive in to Canadian, Texas, at night to meet Wilberforce, and there were so many "light-all" pieces of equipment on the surrounding ranches it looked like hundreds of little cities scattered across the landscape.

We also saw plenty of windmills whose blades seemed to reach as high as the clouds. Truly, between oil field equipment and the wind turbines, the plains had changed from what they looked like when first settled.

Anecdotally, Wilberforce expressed his displeasure for the locations of some wind farms in proximity to lesser prairie chicken leks. He expounded on the nervous behavior of these birds with things from above, particularly raptors that prey on them.

Wilberforce mentioned how noise from the wind generators impaired the prairie chicken's ability to hear in open country. He also said the blades of the turbines create moving shadows and sudden flickers of the sunlight that could be construed as a raptor gliding in for the kill. Wilberforce went on to say that as a result, the birds are subsequently displaced and begin to move to habitats that are less than ideal for reproduction.

His theory seems to have merit, based on a study found in a National Wind Coordinating Collaborative Report titled "Wind Turbine Interactions with Birds, Bats, and Their Habitats: A Summary of Research Results and Priority Questions" in spring 2010. A section in the report points out a 30 percent decline in grouse populations and asserts more study and work needs to be done.

Another study conducted in 2009, by Benjamin K. Sovacool, estimates that wind farms and nuclear power stations are responsible each for between 0.3 and 0.4 bird fatalities per gigawatt-hour (1 GWh = 1000 MWh) of electricity, while comparatively, fossil-fueled power stations are responsible for about 5.2 fatalities per GWh. As a side note, the average household uses approximately 900 kilowatts per month. So, we're talking about a lot of energy.

In *Texas Monthly*'s October 2012 issue, Nate Blakeslee discusses the hydraulic fracking natural gas boom and the many environmental questions that need to be asked.

The article points out that nearly 100,000 defunct wells in Texas remain uncapped, with many of them surrounded by the kind of toxic sludge that drillers once routinely dumped in unlined pits. Additionally, if the state's big drillers were ever forced to completely remediate the fields that have been so profitable to them, the cost would be astronomical.

The article goes on to say that in 2012, the state of Texas had an estimated 270,000 active wells and only 153 inspectors. Moreover, active oil wells are not regulated by the EPA but instead by the Texas Railroad Commission. The question arises, "Can we trust the frackers to do the right thing?"

It must be pointed out that parts of Texas, like Louisiana, act not only as important migratory pathways for birds but also as important summer breeding grounds for hundreds of species—some endangered.

Louisiana continues to fight coastal erosion, which is taking place at an alarming rate, causing severe habitat loss affecting birds and other wildlife.

The state has experienced catastrophic natural disasters in the form of hurricanes that have compounded the effects of land loss.

Louisiana also experienced the worst oil disaster in U.S. history; under one presidential administration, tougher offshore drilling and production regulations were enacted, and under another, they were loosened.

North to south, agricultural practices are changing in our nation, particularly in the upper Midwest, where surface drainage (tiles) removes water from farm fields quickly. The Dakotas act as the "duck factory"; waterfowl use this prairie pothole region as both important breeding habitat and stopover locations during migration. The potholes also provide important habitat for numerous wading birds, shorebirds and passerines. By rapidly removing water and draining potholes, farmers increase tillable acreage.

The reason for tiling? There is higher demand for corn and soybeans than ever before. There also is the need for livestock and cattle feed, as well as ethanol in the pursuit of cleaner energy.

As a result, one of the concerns is the world's oceans are experiencing excessive nutrient pollution from chemical fertilizers (primarily nitrogen), creating dead zones. Dead zones are essentially low-oxygen or "hypoxic" regions in bodies of water that no longer can sustain sea life.

Louisiana and its vast delta receive millions upon millions of gallons of farm, industrial and municipal water run-off annually, forming a dead zone in gulf waters. In 2016, the National Oceanic and Atmospheric Administration predicted the dead zone would be the size of Connecticut.

So, what does all this mean? Does the average American *not* care about the environment? This would be absolutely absurd. Essentially, most Americans deeply care about the environment. They want their children's and grandchildren's world to be safe and pollution free.

However, there also is a reality and common sense about Americans: they understand the need for fossil fuels, agricultural resources and the intrinsic wonder of having a beautiful environment with all of the flora and fauna that goes with it.

Americans hike in the Rockies, jet-ski in the Keys, surf in the Pacific, canoe and kayak in the nation's streams, go four-wheeling in state parks, horseback ride on the trails of the Great Plains, swim in the Great Lakes, go birding in Arizona and other places and also hunt and fish.

In truth, Americans do care. But it's human nature to want and desire a more comfortable and cheaper lifestyle. In light of this, it's incumbent upon all of us—from the energy industry to the scientific community to academia

to us as individuals—to be responsible and do our part in whatever capacity to shape our environment and preserve it for future generations. We can do this reasonably by working together.

No matter where you go or what activity you participate in, birds are there. What's more, the birds along the Louisiana bayou will be waiting for you.

BIBLIOGRAPHY

American Bird Conservancy report. "Status of Black Skimmers 2011—Biological Review." abcbirds.org.

American Wind and Wildlife Institute. "Wind Turbine Interactions with Wildlife and Their Habitats: A Summary of Research Results and Priority Questions." January 2014. https://www.energy.gov/sites/prod/files/2015/03/f20/AWWI-Wind-Wildlife-Interactions-Factsheet.pdf.

Audubon Guide to North American Birds. "Black Skimmer (Rynchops niger)." https://www.audubon.org/field-guide/bird/black-skimmer.

Barnes, Stephen, and Craig Bond. "Economic Evaluation of Coastal Land Loss in Louisiana." Louisiana State University/Rand Corporation, Economics & Policy Research Group. December 2015. rand.org.

Beacham's Guide to the Endangered Species of North America. "Brown Pelican." Accessed February 28, 2018. http://www.encyclopedia.com/environment/science-magazines/brown-pelican.

Blakeslee, Nate. "Fracked into a Corner." *Texas Monthly* (October 2012).

Centers for Disease Control and Prevention. "Avian Influenza A Virus Infections in Humans." April 18, 2017. www.cdc.gov/flu/avianflu/influenza-a-virus-subtypes.htm.

Daniel, Jim. "The Plume Hunters." *Wildlife in North Carolina* 78, no. 3 (May/June 2014).

"Deepwater Horizon Bird Impact Data." Department of Interior—U.S. Army Engineer Research Development Center's (DOI-ERDC) Natural Damage Assessment and Restoration Process (NRDA).

Dell'Amore, Christine. "Oil-Coated Gulf Birds Better Off Dead?" National Geographic Daily News, June 9, 2010. https://news.nationalgeographic.com/news/2010/06/100608-gulf-oil-spill-birds-science-environment.

Department of Interior—Fish and Wildlife Service 50 CFR Part 17. "Endangered and Threatened Wildlife and Plants; Establishment of a Nonessential Experimental Population of Endangered Whooping Cranes in Southwest Louisiana." *Federal Register* 76, no. 23 (February 2011).

Journal of Wildlife Diseases. "Evidence for Seasonal Patterns in the Relative Abundance of Avian Influenza Virus Subtypes in Blue-Winged Teal (Anas discors)." (October 2014).

Louisiana Travel Staff. "Louisiana's Birding Trails." www.louisianatravel.com/louisiana-birding-trails.

Lowery, George H. *Louisiana Birds*. 3rd ed. Baton Rouge: Louisiana State University Press, 1981.

Masson, Rob. "Where Eagles Dare Has Metairie Abuzz." Fox 8, March 1, 2018. http://www.fox8live.com/story/37626836/where-eagles-darehas-metairie-abuzz.

Smith, Nickolas R., Thomas J. Hess Jr. and Alan D. Afton. "History and Nesting Population of Bald Eagles in Louisiana." *Southeastern Naturalist* 15, no. 1 (2016): 12–15.

———. "Winter Breeding and Summer Nonbreeding Home Ranges of Bald Eagles from Louisiana." *American Midlands Naturalist* 178 (2017): 203–14.

Sovacool, Benjamin K. "Contextualizing Avian Mortality: A Preliminary Appraisal of Birds and Bat Fatalities from Wind, Fossil-Fuel, and Nuclear Electricity." *Energy Policy, Elsevier* 37, no. 6 (June 2009): 2241–248.

State of Louisiana. "CPRA Advances Five Components into Design for Calcasieu Ship Channel Salinity Measures." Coastal Protection and Restoration Authority. December 7, 2017. http://coastal.la.gov/news/cpra-advances-five-components-into-design-for-calcasieu-ship-channel-salinity-control-measures.

Valentine, David L., G. Burch Fisher, Sarah C. Bagby, Robert K. Nelson, Christopher M. Reddy, Sean P. Sylva and Mary A. Woo. "Fallout Plume of Submerged Oil from Deepwater Horizon." *Proceedings of the National Academy of Sciences* 111, no. 45 (November 2014): 15,906–911. https://doi.org/10.1073/pnas.1414873111.

Wildbirds.com. "State/Province Checklists." www.wildbirds.com/find-birds/State-Province-Checklists.

Wolfe, J.D., and E.I. Johnson. "Geolocator Reveals Migratory and Winter Movements of a Prothonotary Warbler." *Journal of Field Ornithology* 86 (2015): 238–43.

INDEX

W

Y

ABOUT THE AUTHOR

*J*ohn K. Flores is an award-winning freelance outdoor/travel writer, nature photographer and outdoor columnist for the *Morgan City Daily Review*, *Franklin Banner-Tribune* and stmarynow.com located in Louisiana. In addition to these publications, Flores is a contributing writer for the popular *Louisiana Sportsman* magazine. Flores has numerous credits in both regional and national magazines, including *American Waterfowler*, *Fur-Fish-Game*, *Upland Almanac*, *Mississippi-Louisiana Game and Fish* magazine, *Mississippi Sportsman* magazine and *National Wild Turkey Federation* online magazine.

Flores has lectured on the "Art of Nature," and his *Art of Nature* photography exhibit has been featured in St. Mary and Iberia Parishes for the past year (2017–18), with over ten thousand visitors and guests viewing his work.

To his credit, in 2018, Flores's *Water and Nature* photography exhibit was featured during the Thirteenth Annual Eagle Expo & More in Morgan City, Louisiana.

Flores is a member of the Louisiana Press Association, Southeastern Outdoor Press Association (SEOPA) and the Louisiana Outdoor Writers Association (LOWA). With LOWA, he has served as secretary of the board and served on the Youth Journalism Contest committee.

Flores is a 1990 graduate of the University of Southwestern Louisiana and served his country in the U.S. Air Force (1976–82) for six years.

Flores and his wife, Christine, currently reside in Patterson, Louisiana, where for the past thirty-four years, they raised their four children together.